THE CASE OF THE MISSING LINKS

"In this charming tale of golf and greed, there is enough skulduggery to keep any reader turning pages far into the night. A pair of delightful and romantic sleuths encounter more surprises than they bargained for when they're hired to find a stolen golf course. The loving descriptions of golf courses and how they're built are enough to make even a non-golfer want to grab a club and stroll the fairways."

—Michael Collins
Creator of the Dan Fortune mystery series

"An intriguing mystery involving people in golf course architecture, perhaps the most intriguing and mysterious of all professions. I read Lee Tyler's work twice on a flight from Boston to Los Angeles, and was fascinated."

—Geoffrey S. Cornish
A Past President of the
American Society of Golf Course Architects

"Set in the classic golfing terrain of Pebble Beach, Lee Tyler's novel has all the right ingredients: a dictatorial golf architect, a romantic pair of investigators and a supporting cast of well-drawn characters. The denouement is neatly-plotted and highly satisfactory."

—Malcolm Hamer
Creator of the Chris Ludlow golf mystery series

THE CASE OF THE
MISSING
LINKS

 a golf mystery

Lee Tyler

1999
FITHIAN PRESS
SANTA BARBARA, CALIFORNIA

Published by Fithian Press
A division of Daniel and Daniel, Publishers, Inc.
Post Office Box 1525
Santa Barbara, CA 93102

LIBRARY OF CONGRESS CATALOGING-IN-PUBLICATION DATA
Tyler, Lee, (date)
 The case of the missing links : a golf mystery / Lee Tyler.
 p. cm.
 ISBN 1-56474-302-0 (alk. paper)
 I. Title.
 PS3570.Y48C37 1999
 813'.54—dc21
 98-33103
 CIP

To the memory of two lovable golf gentlemen,
George C. Eberl
and
Burton E. Schwind

ACKNOWLEDGMENTS

For their encouragement, enthusiasm and help in making the story in my head come alive, I would like to thank the legendary East Coast golf course architect Geoffrey S. Cornish and his wife, Carol; Gudren Noonan of the Robert Trent Jones II golf design organization; course designers Kyle Phillips and Don Knott; Dr. John S. Sarconi of Carmel for clarification of some medical matters; and my editor, John M. Daniel of Santa Barbara, who understood my characters even better than I.

Thanks also to my patient "chase" driver, Rosemary Brown, a Pebble Beach resident; Diane Stracuzzi and Margaret Leighton of the Pebble Beach Company; Quail Lodge president Edgar C. Haber; Michael C. Roseto, former president of the Wide World of Golf travel agency in Carmel.

And to: Jan Warren Williams of Coldwell Banker, Pebble Beach; Elvia Arellano of the Monterey Sheriff's Department; Doug Steiny, formerly of the Monterey Search and Rescue Unit; and research librarian Maribeth Forcich of the Burlingame, California, Public Library.

AUTHOR'S NOTE

None of the characters or events in this book are real, although of course Pebble Beach and the Monterey Peninsula are very real.

It is my hope that readers, and especially the residents and visitors who love Pebble Beach, will forgive me for playing around with the geography a bit for the sake of the story.

The would-be golf course described "near Clint's place" could never happen. The beautiful marshy meadow that inspired it is owned and fiercely protected by the State of California.

And of course there is no golf architect's office at Pebble Beach. It exists only in my imagination.

Skylark, I don't know if you can find these things....

—Johnny Mercer

Prologue

Finally he stood on the wind-whipped summit, fifty yards from the elusive green, the surf growling and smashing sixty feet below.

"Hey!"

The call came from the direction of the green. He turned and peered into the dark, where he could barely make out the figure of a man.

"Fore, sucker!" The voice was familiar, but he couldn't be sure, with the wind and the surf muddling the sound.

There was no time to think about it anyway. A glowing ball was speeding through the air, directly at him. A Nitelite golf ball, eerie and beautiful, whizzed by his head and sailed out over the ocean.

Then another. Then another. Like shooting stars they came, and he found himself ducking to stay alive. Whoever was driving off that green was a hell of a golfer. He knew he should retreat, but he was mesmerized by the fireworks. He ducked ball after ball, backing away from the line of fire, until he felt himself slipping, tripping on a root, stumbling, and lurching, his balance gone forever....

First Round

The Lure of the Game

June Jacobs and Harry Winslow were two hours late getting to their office the first Monday in October. Business was slow, the weather was perfect, and they were in love. On a morning like this, with seagulls banking and wheeling overhead, the sun sparkling on the Bay, and the air tasting as clean as peppermints, it wasn't easy to go to work, especially to an office where the phone seldom rang. Instead they strolled, hand in hand, on the Bay Walk beside the San Francisco airport.

"Are you sorry you quit the force?" June asked Win.

"Hell no," he answered. "Now I can take off and play golf any time I want. How about you?"

June shrugged. "I wish we were a little busier."

June and Win were private investigators. They had met the year before when they were both on the Burlingame police force—he their top detective and she the cop assigned to him. Together they had solved a murder case involving a rare and valuable stolen golf ball, they had fallen in love in the middle of an earthquake, and had proceeded with dizzying speed to quit their jobs, move in together, and set up shop as Jacobs & Winslow. The relationship was growing, with the usual fits and starts that new lovers go through. The business, though, was still a game waiting to begin. They'd had only four cases in their first year in business; all of their clients so far had been golf widows wondering whom their husbands were playing with, and each of the cases had been solved easily in the course of eighteen holes. Not much of a career so far.

"We're busy with each other," Win reminded her. "We work for ourselves. That's got to count for something."

June smiled, watching a jumbo jet lift into the air, bound who knew where. "Aren't you kind of itchy to go somewhere exciting, do something dangerous and important?"

Win patted her on the tush. "Yep," he said. "I'd like to go out to Crystal Springs and play nine holes before work, then check into the office and find out nobody's called, then go home for lunch, take a nap with you, maybe even catch a few winks, then get in another eighteen holes before the six-o'clock news."

"Well, I'm glad I'm at least part of your long-term goals," she answered. "But in the meantime, we'd better get to work. I'll find something to do while you putt around the carpet."

"Okay, boss," he grinned. "Race you to the office." With that, he took off running. June watched him as he sprinted away from her, his trim, athletic body a pleasure to behold. She gave him a fifty-yard head start, just for the pleasure of all that beholding, and then took off after him, catching up easily and passing him before they reached the crosswalk for the Old Bayshore Highway.

Laughing and out of breath, they burst into their office, flipped on the lights, and opened the windows wide. Win picked up three golf balls from his desk and started juggling, and June made coffee. Then she noticed the blinking green light on their answering machine.

"Good Lord, partner!" she cried. "We've got five calls! And it's not even ten o'clock!"

"Did you remember to pay the rent?" Win asked.

June ignored him, sat at her desk, and hit *play.*

"Message one, 8:02 A.M. 'This is Sheldon R Moore the Third in Pebble Beach. Call me at (831) 555-4653. Right away.'"

"Message two, 8:21 A.M. 'Sheldon Moore. Maybe you didn't get my message. I need you to call me *now.* (831) 555-4653.'"

"Message three, 8:45 A.M. 'Jesus, what kind of business is this,

anyway? Your answering machine says you open at eight. God damn it, I want a call back. I'm used to dealing with professionals.'"

"Message four, 9:00 A.M. 'Okay, okay, my secretary says I have to say please. There. *Please.* I'm giving you till 9:30, and then I'm going to call a local detective agency down here.'"

"Message five, 9:45 A.M. 'Listen you flakes, this is your last chance. I've got a good piece of work for you here, and there's money in it, and in case you haven't heard of me I'm the highest-paid golf course architect in the world, and I deserve at least the courtesy of a phone call. I need some detective work done, and I need it *now.* Let's go, folks, I'm not used to being ignored.'"

June looked up from her desk and watched Win juggle the golf balls. "Want to hear any of those messages again?"

"Nope," he answered, letting the balls drop, one-two-three, onto the carpet. "Once was enough. Did you get the phone number?"

"I did." She handed him the slip of paper.

"Do you realize who this guy is?"

"Of course," she bristled. "He just told us."

Win sighed, sat at his desk, and picked up his phone. "He doesn't sound like anyone we want to work for," he remarked.

"We need the work, Win."

"I know, babe, but we agreed: we don't work for jerks."

"Just give him a call," June said. "Take charge. If you don't call, I will."

Win punched the numbers, and at a nod from him, June picked up her receiver and listened. On the third ring, a sultry female voice answered. "Mr. Moore's office."

"This is Harry Winslow, returning Mr. Moore's call."

"One moment."

June and Win exchanged looks.

"Winslow?"

"Speaking."

"Yeah. Look. You're the one that found that featherie, right?"

"That's right," Win answered. It was the world's rarest golf ball, a treasure to die for. Or to kill for. In fact....

"I read about that in *Golf Digest*. I guess you're quite a detective, and I assume you're a golfer."

"Guilty on both counts," Win admitted.

"What's your handicap?" Moore wanted to know.

"Listen, Mr. Moore, I'm very busy this morning," Win answered. "Perhaps you should get to the point. What can I do for you?"

"Well, if you're so good at finding things, I want you to come help me find something. How soon can you get here?"

"What have you lost? If it's a ball in the rough, there's not much I can do for you. That's what caddies are for."

"It's bigger than a golf ball, kid. Can you be here for lunch?"

"I'm afraid I've got a busy schedule today," Win said. "Let's see, appointments at 10:30, 11:15...." June rolled her eyes and covered her receiver while she snorted.

"Nothing you can't break," Moore told him. "I'll make reservations for lunch. Are you going to bring your assistant?"

That was more than June would shut up and listen to. "Mr. Moore," she broke in, "I am not Mr. Winslow's assistant. I'm a full partner in this business. We work together."

"That's quite a little woman you got there, Winslow," Moore said. "So I'll expect the two of you for lunch?"

June nodded her head. Win shook his, and said into the phone, "Sorry, Mr. Moore. Don't see how we can make it today. It's been such a rat race up here, we're taking the afternoon off to play golf."

"Oh yeah?" Moore replied. "Where?"

"Crystal Springs," he said.

"Public course," Moore said, an audible sneer in his voice.

"That's right, till business picks up."

"Wouldn't you rather play Pebble Beach?"

"Not till business picks up," June butted in. "Pebble Beach may be public, but it costs three hundred bucks a round."

"Forget the cost," Moore snapped. "This round's on me, if you'll come down here right now, today. What do you charge, by the way?"

"A hundred dollars an hour, plus expenses," Win said.

June's jaw dropped. Their usual rate was seventy-five. She'd never known Win to fudge his handicap.

"I'll double it. Then it's a date for lunch?"

Win grinned into the phone and then winked at June. "We'll be there. Say, what is it you want us to find?"

Sheldon Moore paused before replying, softly but violently, "Some bastard's stolen my golf course!"

 Forewarning

"Win, how *could* you?" June sputtered after they had both hung up. "You let him walk all over us."

Win was already over at the office closet, pulling out the get-away luggage. Jacobs & Winslow had been packed and ready to travel since the day they hung their shingle, but the suitcases had not yet been used. "You don't want to go?" he asked. "You don't have to, sweetheart. I can handle this case alone if you want to stay here and take care of the office."

"Baloney," she answered. "You couldn't handle a case alone, not without your loyal *assistant*."

"Now, June...."

"You heard the man. 'Let me give you directions, honey.' He thinks I'm your secretary. What a creep." She unplugged the coffee pot and reset the answering machine.

Win chuckled. "Maybe he was just hitting on you."

"Even worse," June fumed. But she crossed the office and hefted her suitcase. "Let's go," she said.

"You're sure you want to do this?" Win asked, as he locked the office door.

"Yes, yes," she sighed, tagging behind him across the parking lot. "Of course I'm coming. For one thing, you couldn't read a road map without me; for another I'd like to see how anyone could be stupid enough to lose an entire golf course. And...."

"And?" Win opened the trunk of his blue Mercury Tracer.

"*And*, I didn't like the sound of that receptionist," June said, tossing her suitcase on top of Win's golf clubs. "I'm keeping my eye on you, buster."

June pouted silently all the way down the Bayshore freeway, past Redwood City, Palo Alto, and Silicon Valley. She even kept her mouth shut through San Jose although it was hard not to complain out loud about the traffic. But her mood lightened up as they drove south past Gilroy, where the air was still fragrant from the garlic harvest. The hills were brown, the sky bright blue, and Highway 101 was like a garden lane, with colorful splashes of deadly but gorgeous oleander and rows of stately white eucalyptus trees.

When they turned off on 156, a rural road bound for the Monterey Peninsula, she finally opened up. "Sure doesn't look like the way to a golf mecca," she remarked.

He chuckled in agreement.

"Okay," she said. "I admit it, I'm glad we're doing this job. We needed to get out of town, and Lord knows the business could use a little cash. What I want to know is what makes you so eager to work for this guy? Have you heard of him before?"

"Of course," Win answered. "He really is one of the most famous golf course designers in the world. I've played a lot of his courses."

"What else do you know about him?"

"According to locker-room gossip, he's impossible to work for.

A mean son of a bitch. Vain, skirt-chasing, hard-drinking, foul-mouthed, egotistical, back-stabbing, tight-fisted, and paranoid to boot. Will that do?"

June laughed out loud. "So why do you want to work for this lovely fellow? We don't need the money that bad. What's your motive, as we private eyes are wont to say?"

Win chuckled, "You're a private eye. You should be able to figure it out."

June chewed on it, along with a piece of Trident gum, while they sailed by Castroville, the Artichoke Capital of the World, and then passed a series of drab hamlets with handsome names: Marina, Sand City, Seaside. Then they rounded a bend and the dramatic sweep of Monterey Bay came into view, banked by dark forested hills.

"God, I'd forgotten how beautiful it is," June said. "I haven't been here for years."

"I get a thrill every time I come down," Win admitted. "Of course," he added hastily, "that hasn't happened since I met you. Except on television. A lot of golf tournaments happen around here."

"I know," June sighed. She was well aware of Win's television viewing habits. Generally an athletic man, he was a sucker for a golf show.

"You're right," he agreed. "It is beautiful. Even better than on TV."

Signs directed them to keep straight for Carmel, but to bear right quickly for Pacific Grove, then Pebble Beach, and finally, Seventeen Mile Drive.

"Wasn't that our turn?" June pointed out. She had to admit she enjoyed the chance to correct him.

"Actually it wasn't," Win answered. "It's more direct if we go in by the Carmel Gate."

"How many gates are there?"

"Five."

They followed the signs to Carmel and then, with June reading from Sheldon Moore's instructions, they navigated through the picturesque town, dodging the pedestrians at every corner, until they almost reached the Pacific Ocean. Then they turned right on North San Antonio and followed it a short way to a rustic gatehouse, where a barrier stopped them from going any further.

A security guard dressed like a park ranger, complete with Smokey Bear hat and a shiny star on his chest, ambled forth to greet them. "Howdy, folks," he said. "That'll be seven dollars and fifty cents."

June fumbled with her purse, but Win put a hand on her knee and said to the guard, "I have an appointment with Sheldon R Moore."

"Oh," the guard replied. "You are—?"

"Winslow."

"Ah yes. Mr. Moore called and told us to expect you. Do you need directions?"

"No thanks," Win said. "I know my way around here."

June leaned across him, smiled sweetly at the guard, and said, "Please, sir, *I'd* like a map. My driver thinks he knows his way around here, but I'm the navigator."

The guard chuckled and handed her one, then stepped aside and raised the gate.

"What was all that about?" Win asked as they drove away from the gatehouse and followed Seventeen Mile Drive into the private forest.

"All what?"

"You sound a bit pissed off," he pointed out.

"'*I have an appointment*'? '*I*'? What happened to *we*?"

"Oh, yeah," Win said with a nervous chuckle. "Well, I'm the one he called. You didn't even want to come."

"I'm here, aren't I?"

"Enjoy the scenery, sweetie," Win advised. "This is a great place."

She had to admit it was. The road wound through a well-tended hilly forest pocketed with tasteful and elegant mansions and estates. Finally the road swooped down a hill and before them lay the storied Pebble Beach Golf Links, with its elegant hotel, the Lodge at Pebble Beach, and a small community that served as a commercial center. June heard Win suck in his breath and whisper, "My God you're beautiful!" She turned to him, growing a grin, only to realize he was speaking to the golf course, not to her.

"Well, this is it," she said, consulting Moore's directions as they rolled alongside a scattering of early California mission-style buildings with red-tiled roofs and clipped green lawns. "That's Moore's building there, on the corner. Sheldon R Moore Golf Course Designs."

Win pulled to a stop and cut the engine of the Tracer. He turned to June and said, "Honey, I apologize. I'm really glad you're with me. I couldn't do this without you. I'm sorry I acted like a big shot. Okay?"

What a nice man, June thought. Not to mention drop-dead gorgeous. "Okay," she said. "Sorry I got touchy. But one thing still bothers me."

"Yes?"

"Win, why the hell are we here? I can't figure it out."

"Simple," Win answered. "I've always wanted to play Pebble Beach, and he's offered me a free game."

Teed Off

Barbara Sutton was ready to spit a divot.

It was bad enough that her boss had expected her to work straight through the weekend, all day Saturday and all day Sun-

day, unrolling every single golf course design in his archives, looking for Skylark. It wasn't easy getting the designs out of their tubes, and it was even harder shoving them back in; they were huge plans, six feet by three, and had to be rolled up tight as a pencil.

As if anyone would hide Skylark in there. As if anyone would have had the opportunity. Nobody went into Sheldon's inner office without passing Barbara's oval rosewood desk and her scrutinizing eye. So if Sheldon insisted that Barbara sift through that closet, it meant he suspected her of letting someone in his office without telling him about it.

Worse than that. He had seemed to enjoy watching her go through the chore of unrolling every damn design. He had checked each one, as if she couldn't do the job by herself. As if she wouldn't tell him the truth. As if she had stolen the darned thing and hidden it herself.

Furthermore, on Saturday, when he sent her out for sandwiches, he had gotten the designs all mixed up before she could refile them, confusing the ones she'd opened with the ones she hadn't, and she had to do the morning's work over.

What a meddlesome, controlling, infuriating....

And yet, Barbara could remember how he'd been not that long ago, when she would gladly drop everything and spend a weekend with Sheldon R Moore III. As his personal assistant, she would make false plans to visit the site of a golf course project that didn't exist, and then the two of them would steal away down the Big Sur coast and spend the weekend in Morro Bay. They would play golf together on the public course, under assumed names, and then drink martinis at the Inn at Morro Bay and watch the sun set behind Morro Rock before retiring to the bliss of a sweet and tacky motel room.

He could be a charming man, for a power-hungry egomaniac. Attentive, even gentle, and a first-class lover, bringing cherries and champagne, chocolates and cognac.

But that was before Sheldon went to the islands of Tonga,

deep in the South Pacific, to discuss a potential golf course with an island chief. Two months later he'd returned, not with a contract, but with a new personal assistant, a Polynesian honey who couldn't type, spoke almost no English, and didn't know the difference between a golf ball and a coconut. Sheldon put Selia on the payroll so she could bring him his coffee and carry plans and papers from office to office, with undulating hips and a smile that twinkled with suggestion.

Barbara had stayed on as Sheldon's front office wizard. Sheldon hadn't dared let her go; she knew too much about the business, and too much about him, for that matter. But she was no longer his lover. In fact, he had the nerve to tell her whenever he and Selia went out of town on "business." He even had Barbara make the reservations, phony ones at nonexistent golf course sites, with the real reservations at the same motel in Morro Bay where he and Barbara had spent so many happy nights.

And now, here she was in the office for the eighth day in a row, working through her lunch hour on Monday, because the great Sheldon R Moore III told her she couldn't leave her desk until his appointment showed up. Barbara Sutton was hungry and she was fed up. Mainly she was itchy for revenge.

She reached into her top desk drawer and pulled out a dart. She glared across the office at her boss's smiling face. She stood up from her desk, cocked her arm, and hurled the dart straight at Sheldon R Moore III's stupid, smug grin.

4 The Keeper of the Greens

Win held the door open for June, and they walked into what appeared to be the world's biggest reception room. Not that the room itself was terribly large; it was apparently the parlor of what

had once been a private home. But the walls!

Each wall was a painted mural—floor to ceiling, wall to wall. Each mural depicted a different golf course, with a teeing ground in the foreground and a vast expanse of fairway stretching far into the distance toward the pennant of a green. There was blue sky and some water here and there and a few white sand traps and dark trees, with green the overwhelming color of the room. And in the foreground of each mural stood a smiling life-size foursome. Win recognized some of the players that were teeing off in all four directions: Bob Hope, Glen Campbell, Arnold Palmer, Jack Nicklaus, Prince Andrew, George Bush, and Spiro Agnew. Curiously, there was one man who was a member of every foursome, a nice-looking, middle-aged fellow wearing an expensive golf shirt and a confident smile.

"Wow!" June exclaimed. "I feel like I've just walked outdoors."

The carpet, of course, was green. The ceiling was sky blue.

In the center of the room was a handsome desk, behind which sat a beautiful woman. Win sized her up quickly: luxurious black hair in a French twist, pert nose, defiant chin, turtleneck sweater—green, of course, and nicely contoured. Win could almost feel June's disapproval of such an observation, but hey, he was an investigator, right? Paid to notice things.

The woman looked up and said, "May I help you?" Nice eyes, too. Sapphire, catlike, full of the devil. Her smile had perfect teeth and no warmth.

"How do you do," Win said. "My name's Harry Winslow and I have an appointment with Mr. Moore."

The woman consulted her datebook, glanced at him coolly, and shook her head. "I'm afraid you've made a mistake," she said. "Mr. Moore is tied up all afternoon."

Win's heart sank. His first, maybe his only, chance to play Pebble Beach; was it too good to be true? "Are you sure?" he asked the woman. "If there's any mistake, it's his, or possibly

yours. I just talked with him a couple of hours ago. He specified that I should meet him here by noon. Right, June?"

June nodded.

The beauty behind the desk calmly punched a button on her intercom and said, "Mr. Moore, do you have an appointment I don't know about?"

"Hell yes," growled the voice Win had heard only two hours before. "Why? Is he here, finally?"

"Please announce Harry Winslow," June told the woman. "From Burlingame."

The woman blushed and mumbled, "Oh, excuse me. And you are…?"

"June Jacobs. I'm his associate."

The woman pressed her button again and said, "Your appointment has arrived, sir."

Win took a deep breath and surveyed the front office. He recognized one of the fairways: hole number five of Dinosaur in Utah, a Sheldon Moore course that Win had played only last spring.

A door opened in the middle of the mural, and Arnold Palmer swung out of the way. Through the door stepped the man whose likeness appeared in all the foursomes on the walls, though a bit balder in real life. For such a successful man, Sheldon R Moore III was surprisingly unimpressive face-to-face. He stood about five feet nine, with the posture of someone trying to appear a bit taller than he was. He was balding, his hair fussily cut and arranged to cover most of his skull. He had brown eyes that appeared sincere, almost childlike. He wore a houndstooth sportcoat over a cream dress shirt, a club emblem necktie, well-cut corduroy slacks, and shiny brown loafers. He strode into the room with his hand outstretched.

"Sheldon Moore," he announced. "And you must be Winslow."

The two men pressed flesh and then Moore turned to June.

"And you, I gather, are the equal partner."

June smiled and shook his hand.

Moore winked at Win and said, "You have good taste in equal partners. Shall we step into my office? Oh, excuse me, this is my secretary, Barbara Sutton. She keeps us all in line, right, Barb?"

Barbara Sutton did not answer. She gave the briefest of smiles, then returned her attention to her computer screen.

The carpet in the private office of Sheldon R Moore III was green, of course, and right in the center of it was a sunken cup. Several Titleist balls were scattered around the floor. But what caught Win's keen attention was the umbrella stand full of putters. Even from across the room he could name the brands, sticks he'd been dying to get a grip on: the Plop, the Bull's Eye, the Zebra....

"Don't trip on the golf balls," Moore cautioned them. "I don't need a lawsuit on top of everything else. Siddown, you two."

They sat in a pair of wingback leather chairs, and the architect took his place behind his massive desk.

"Nice office," June offered.

"Thanks," Moore responded. He turned to Win and said, "So. You found that featherie. So."

It was time to cut through the formalities and get the case closed if they were ever going to get out on the Pebble Beach Links. "You say your golf course has been stolen?" Win prompted.

"You're god damned right," Moore snapped. "I expect you to get it back for me."

"You'll have to be a little more specific," Win said. "Just exactly where is this golf course?"

"Jesus, man. If I knew where it was, do you think I'd be paying you two hundred dollars an hour plus expenses?"

June said, "Mr. Moore, do you mean to tell us that an actual golf course has disappeared? You don't mean it was stolen in the sense of a hostile takeover or a missing title or...."

"It's the damn golf course that's missing," Moore said. "Somebody took it. Stole it."

"With what?" Win asked. "Earth movers? That sort of heist usually gets noticed."

"Oh, don't be ridiculous. It was the *design* of the golf course, naturally. Not the actual course. That hasn't even been built yet."

"I see," Win said. "That makes better sense. How much is a design like that worth?"

Moore snorted. "To you, it's worth two hundred bucks an hour. To me it's worth about five million dollars and not getting my legs broken. Or worse."

"What's it worth to a thief?" June asked.

"That's for you to find out," Moore said. "I want to know who took it, and why, and I want it back."

"Sounds doable," Win said.

"By Thursday," Moore added.

"Why Thursday?" June asked.

"That's when my client's flying in to see the plan. He's a sultan from Malaysia. He's already paid me five million and he travels with a bunch of Mongol goons for bodyguards. Let's just say it would be a serious mistake for me not to be able to deliver on this deal. You get me?"

"Okay," Win said. "Let's get some information. What does a golf course design look like?"

"Like a golf course," Moore snapped.

What a bozo. Win took a deep breath and tried again. "How big are the plans?"

Moore stood up and walked to a wall closet and opened it. There were hundreds of tubes, stacked on shelves. He pulled out a tube and opened it, then withdrew and unrolled an architectural rendering of a golf course. "Three feet by six, but it all fits in this tube."

"I assume you've looked through those tubes to be sure it wasn't accidentally misfiled?"

"Of course. And by the way, it wouldn't have been misfiled by accident. I don't allow that kind of sloppiness around here. My secretary and I checked every one of those designs."

"How about that one?" June asked, pointing at a long rectangular tube resting on a couch.

Moore walked over to the couch and picked up the cardboard box. "That's not a plan," he said. "It's a putter." He opened up the tube and withdrew a T-Bone, which he added to the collection in his umbrella stand.

Win eyed the T-Bone enviously. What a treasure! Then, catching a glance from June, he got back to business. "Who knows about the missing design?" he asked.

"Everybody in the office."

"Any idea who might have done it?"

"Had to be somebody on the staff. There are six of us here, and you can rule me out. That leaves five possibilities."

Win scratched his cheek. "Presumably the design has no monetary value to anyone but you and this sultan. It has to do with a specific piece of land, and that's owned by either you or the sultan, and the plan wouldn't fit anyplace else, right?"

"That's right."

"So why would somebody steal it? What's the motive?"

Sheldon R Moore III narrowed his eyes and stared right back. "To get me."

"To get you?" June said.

"You heard me," Moore hissed, his eyes darting from her face to Win's. "You find out who, and you find out why, and I'll take care of the rest."

"But who in this office would want to get you?" Win asked.

"Take your pick," Moore answered. "I don't trust a one of them, and you shouldn't either." Then he turned to June, smiled, and with a courtly bow said, "Let's go to lunch."

⛳ Private Course

Andy Putnam gazed at the expanse of green before him. What a beautiful sight! The rolling fairway of hole six, a par five, 478 yards of glorious grass, a tiny yellow pennant fluttering in the distance like a flirt.

Andy teed up, selected his driver, and gazed again into the distance. He consulted his caddy, who told him, "The wind's fairly strong from the east, so you'll want to shoot a little to the left. Not too far, though; there are a couple of mean bunkers on the left side."

Which Andy knew, of course. He had put those bunkers there himself, only an hour ago.

As for the wind, he turned it down a little bit. He also softened the glare off the water on the right side of the fairway. When things were just the way he wanted them, he hit "Swing."

Swish. Thwack. Fore! The sounds on this machine were great. Including *Plop*. Right in the water.

Andy pulled down the action menu and clicked on "Mulligan."

A new ball appeared on his tee. "Swing."

Swish. Thwack. Fore!

That was more like it. The ball bounced happily in the center of the fairway, which was also the center of his screen, and the caddy's voice said, "Way to go, pal."

The option menu asked him if he wanted to walk or ride, and he chose walk. He needed the exercise.

Like a lot of people on the Monterey Peninsula, Andy Putnam, known to his colleagues as Putt, played a few holes of golf every lunch hour. Unlike most of them, however, Andy had never set foot on a golf course. He did all his golfing on his computer, at his desk in his office, between bites from a sack lunch.

He chose a 3-wood. Teed up. *Swish. Thwack.* "Nice," said the

caddy's voice as the ball landed in the rough but very much in play.

Putt probably wouldn't have been much of a golfer. He was overweight and antisocial, preferring the company of computers to people, fluorescent light to sunshine. He was the webmeister for the golf course architectural firm of Sheldon R Moore III, as well as the nerd in charge of computer graphics. He designed brochures, schematics, and working plans for the company. He had tricks up his sleeve that made him invaluable among his colleagues. He could move trees around in seconds, he could change Bermuda grass to rye with a single keystroke. Want a bunker or two? No problem. Water hazard? You got it.

Of course, nobody in the company appreciated him. They thought he was weird. Doug, the artist and chief designer, hated computers, preferred to do all his designs by hand, using pens and paintbrushes and other dark-age tools that went out with carbon paper and Letraset. Chip, the company agronomist, made fun of his clothes, called him "the hacker." Barb, the stuck-up secretary, never gave him the time of day.

But the worst was Sheldon R Moore III.

The boss knew nothing about technology, made fun of it, had no idea how lost he'd be without computers, underpaid his staff, demanded long hours, took long lunches, and grabbed all the credit. He had never once said a kind word to Andy Putnam, had never once praised his work.

Well, fine. Andy had plans. Long-range plans.

In fact, Andy had *the* plans.

He chipped across the bunker and bounced on the green, rolling five feet from the cup.

During the three years he had worked for Sheldon Moore, he had designed a dozen computer golf games based on Sheldon Moore designs. All on his lunch hours, never stealing a minute from the company.

Not that Andy Putnam was above stealing.

He pulled down the "Sticks" menu and selected "Putter."
Putt's golf games were going to make him rich.
Especially the new one.
In for a birdie.

6 Rules of the Game

Sheldon R Moore III led the way as if he were used to being fol-
lowed. Half a step ahead of Win and June, he strode along the red
brick path that linked his office building with the crosswalk span-
ning Seventeen Mile Drive. "You're going to like Club XIX," he
told them. "We'll be able to talk there. It's a quiet place and they
don't cram the tables close together. More privacy. Let's cross
now."

Win and June followed behind, hand in hand, as Moore took
them through the entrance to The Lodge at Pebble Beach and its
world-famous Golf Links. June felt Win's hand tighten on hers as
he whispered, "There's the pro shop up by that big clock. I can
hardly wait!"

"I assume we'll get to eat first," June whispered back. "At least
I hope so. I'm starved."

They walked by a practice green in the center of a shopping
oval, where golfers were waiting for their tee times. Sheldon
paused to watch one of them putt. He clucked his tongue loudly
when the ball, from a distance of only two feet, missed the cup.
The edgy golfer shot him an angry glare.

The threesome crossed the porte-cochere and were greeted
by two nattily suited young men, who opened the door to the
Lodge.

Inside, they were greeted by a smiling bevy of reception
clerks, who chorused, "Hello, Mr. Moore."

"Hi, girls," Moore replied. He turned to Win with a grin on his face and said, "See why I like this place?"

Right, June thought. All a man could want: servants to open the doors, girls to stroke his ego, and eighteen holes of golf. As for me, I want to see a menu.

She didn't have to wait long. Moore led them down a hall, past the Tap Room, and down a flight of stairs to the ground level and Club XIX.

The maître d' swung open the iron gate and bowed with continental flair. "Very nice to see you, Mr. Moore," he intoned.

"Joseph," Moore acknowledged. "My secretary called?"

"Indeed she did, sir," Joseph replied. "Your table is ready. On a day like this I presumed you'd prefer to lunch outdoors?"

"Very good. Lead on." They followed the maître d' through the large clubby dining room outdoors to a red-tiled terrace flanked on either end by cheerful open fireplaces. Tables were attractively set with sparkling crystal and gleaming silver, and through the transparent windbreak they had the glorious view of Pebble Beach's finishing hole backed by the shimmering Pacific. Joseph seated them and handed them their menus, bowed, and backed away.

June opened her menu and scanned the selections, but before she could make a decision, Sheldon Moore said, "If you don't mind, I'll order for you. I know what's good here."

What a control freak, June thought. Oh well, if you're paying I guess you get to be in charge. She closed her menu, determined to come back here soon with Win, alone.

A lanky, whip-faced man ambled out onto the terrace and gave Sheldon Moore a grim smile and a nod as he passed their table.

"I've seen that man before," Win said quietly.

"I expect you have," Moore replied. "He used to be mayor of Carmel. I play golf with him occasionally."

"How's his game?"

Moore chuckled. "Well, let's put it this way. Playing with him's a pleasure. Betting against him makes my day."

A waiter appeared and hovered while Sheldon Moore gave the order: "Quiche tartlet with spinach for the lady. Your shrimp and crabmeat salad for my other guest. And prawns Provençale for me."

Joseph reappeared with a wine list, but didn't hand it to Moore. Instead, he said, "May I recommend the Far Niente Chardonnay. A bit fruity, but…." He shrugged and pursed his lips.

"You're the boss, Joseph," Moore replied.

When the wine was served and they were toasting each other, June said, "Mr. Moore, I'd like to ask you a question."

"Wait a minute," the client interrupted. "A few rules of the game. As far as I'm concerned this business we're doing is like a game of golf. It's got rules. And rule number one is we call each other by our first names. Agreed? Call me Sheldon."

"Very good," Win agreed. "We're Win and June."

"Sheldon," June said, "here's my question. What's the R stand for?"

"R?"

"As in Sheldon R Moore the Third."

"Oh, that. Doesn't stand for anything. It's just a bit of class. Like Harry S Truman or Toys R Us. Actually, I wanted something to distinguish me from my father, who used to be the most prolific golf course designer in the world."

"Used to be?" Win asked. "I thought…."

"Till I came along," Sheldon said. "I've designed more Moore courses than both my father and my grandfather combined. Each one better than the last. I don't mean to brag, but you might as well know who you're working for. I am known as the best, because I am the best. And this new golf course, the one you're going to get back for me, is my masterpiece. It will be the envy of the entire world. That's what's at stake, folks. That's why you're here. Ah. Here's our food."

"Where is this golf course?" Win asked. "Not the plans, the actual location of the course. Where's it going to be?"

"You don't need to know that," Sheldon replied. He popped a prawn into his mouth. "It's the design you're interested in, not the place. That's another rule in this game."

One thing June had to admit. Sheldon was a blowhard, but he had good taste in food. Her spinach tartlet was a gem. "Does the course have a name yet?" she asked.

"We're calling it Skylark," Sheldon answered. "That may change. We're getting an image consulting firm in on this, but for now it's Skylark. So June, do you play golf?"

June shook her head. "No. I don't think I have the temperament. I'm an impatient person, you see. And very competitive."

"So?" Sheldon replied. "I'm impatient. I'm competitive. And I play golf. Very well, by the way."

Win put his hand over June's and said, "Someday I'll get her out on the course. In the meantime, I'm looking forward to playing with you."

"Maybe someday we'll have the chance," Sheldon said. "I'd enjoy that."

June felt Win's fingers tighten on her hand. "Aren't we going to play this afternoon?" he asked. "I thought that's what you said on the phone."

"Are you nuts?" Sheldon laughed. "I got you down here to work, Mr. Winslow. You find those plans for me, and then we'll have plenty of time left over for golf. Work comes first. That's rule number three."

"Okay," Win said, his expression pleasant. June knew that "pleasant" expression, and just what it meant. "So who did it? Do you have any ideas?"

"Any one of them," Sheldon replied. "At the moment my hunch is Doug Banner, my right-hand man, assistant designer. He's the one with the most opportunity. But it could have been any one of them."

"Then we'd better meet them all," Win said. "Can you call a meeting?"

"Sure thing," Sheldon answered. "Soon as we get back to the office."

June was glad to see Win at work, finally. He was happiest when he was solving a case. Well, he was probably happiest when he was playing golf, but June never got to see that. Of course, there were other ways she got to see him happy....

"Have you played any of my courses?" Sheldon asked Win. "Moon River in Oregon? White Dunes in South Carolina?"

"I haven't played those yet," Win answered. "But my buddies and I used to play Waihee in Hawaii every year, back when I was on the police force and could afford to travel. Those were the days."

June wondered what that meant. Was she cramping her lover's style?

"How about Silver Horseshoe in Virginia? Par 74. Been there yet? Tumblewood? Bonanza? That's a par 73."

Enough, already, June thought. But Win was obviously enjoying this. Golfers talked a language from Mars. "I played Dinosaur last April," he said. "In Utah."

"Yeah, I had a lot of fun heaving the earth around for that baby," Sheldon said.

The man thinks he's God, June thought. Well, maybe he is, but it's time to get back on track. "Are you going to have to move a lot of dirt for Skylark?" she asked.

Sheldon narrowed his eyes. "Why do you ask?"

"I'm trying to find out a little bit about this design," June answered, sweetly, forcing a smile onto her face. "The one we're looking for."

Sheldon waved a hand in front of his face, possibly telling a waiter that they'd finished their entrees, possibly telling June to mind her own business. "The design," he said, "is six feet by three. It fits in a cardboard tube. It was stolen by someone in

my office. That's as much as I can tell you. You take it from there."

A waiter whisked away the plates, and the threesome sat in awkward silence until another waiter brought a lemon sorbet, which June found delightfully tangy.

"The land," she said, when her courage had returned. "Skylark. Do you own it?"

"You could say that," Sheldon Moore answered.

"If I did, would I be telling the truth?" June asked.

Sheldon gave her a blank stare, then turned a softer face to Win. "Truth is like golf," he replied, addressing the man who spoke his language. "It's not an exact science."

 Playing by the Book

Sheldon led his team of investigators around behind the office building to the backyard. Sitting on the patio was a young man reading a book. The young man stood up and smiled. He wore a plaid shirt, clean blue jeans, and hiking boots.

"What are you doing out here, Chip?" Sheldon asked him. "Are you still on your lunch hour?" He consulted his watch. "Holy cow, kid, it's almost two o'clock. I don't pay you to sit around reading."

Chip put the book behind his back and said, "Sorry, Mr. Moore. I was doing some research, and...."

"What's that book?" Sheldon demanded.

"It's just...."

"Let me see it."

The young man handed it over, and Sheldon read the title aloud: "*Ethical Landscaping in Fragile Environments.* What's this got to do with golf?" he grumbled.

"Everything."

"Huh?"

"It's got everything to do with golf, Mr. Moore," the young man said. "I'll get back to my office now." He held out his hand and Sheldon gave him back the book.

"Oh, Chip?" Sheldon called after him. "We're having a meeting in the conference room at two o'clock. All of us. Tell Putt, will you?"

"Okay," Chip said. He disappeared into the building.

Sheldon turned to Win and June and said, "These young kids think they know everything. 'Ethical landscaping,' what's that supposed to mean? Golf courses add beauty to the landscape, that's all I know and all I need to know."

"What does Chip do for you?" June asked.

"He's my agronomist. He's the expert on landscaping—trees, turfgrass, soils, irrigation, technical stuff. I pay him more than he's worth, but, as Samuel Goldwyn once said, he's worth it. He's got radical ideas, though. I'd like to get rid of him."

"Why don't you?" Win asked.

"He knows too much," Sheldon said in a fierce whisper.

"About?"

Sheldon paused a moment and then said, "Trees, turfgrass, soils, irrigation, technical stuff. Whether I like him or not, he's the best in the business. Shall we go in?"

 The Pros

The conference room of Sheldon R Moore Golf Course Designs had at one time been the master bedroom of a private home. Now that that house had been converted into an office building, the room had none of the hominess of a bedroom, but all the author-

ity conveyed in the word "master."

Especially today. The atmosphere vibrated with tension.

In the center of the room was a large oblong teakwood table. Sheldon Moore sat at one end, and on either side of him sat Win and June. Barbara, the secretary, sat next to June. The other seats were occupied by Chip and two other fidgeting men whom Win and June hadn't yet met.

"Are we covered out front?" Sheldon asked Barbara.

"Yes, sir," she answered, her voice crisp. "I told Selia to mind the desk and the phones. She knows we're not to be disturbed."

"Fine. Let's get started." He turned to Win, and said, "As you can see, we're a very small staff. And as you can imagine, in a business this small, everybody knows everybody very well, and everybody is pretty much aware of everything that happens all day long around here. Right?" He looked around the table. "Right?"

His staff nodded.

"We're a bunch of know-it-alls," Sheldon said, chuckling. "Can one of you know-it-alls tell our guests here why, even though we're a very small company, we have such a large conference table?"

The man at the other end of the table said, "It has to be big. This is where you show the designs to your clients."

"Bingo," Sheldon replied. "That's Doug Banner, my assistant designer," he told Win and June. "He does the final rendering on my designs. And you already know how big those designs are. Now can somebody please tell me why there is no design on this table right now?"

Silence.

"Come on, people, I want an answer."

Still no one spoke up.

Sheldon pressed on. "I've got two important clients here, and I want to show them my latest project. I want them to see Skylark. Why isn't Doug's rendering for Skylark here on this table? Barbara?"

"Because we can't find it, sir," Barbara answered. "As you know."

Sheldon slapped the table with his palm and stood up. "Oh, but we *can* find it," he said, very clearly, very calmly. His gaze went around the table, stopping on each of his four staff members. "And we will. Because I've brought in a team of private investigators, and it's their business to find things. And I happen to know these people sitting beside me here are good at what they do, just as I am good at what I do. People, I'd like you to meet Harry Winslow, on my left, and June Jacobs, on my right."

The group responded with a mumble of interest. "We've heard about you," said the older man at the far end of the table. "*Golf Digest* is required reading in this office. You two solved that murder mystery last year, right?"

Win and June smiled at each other and at the staff. Harry said, "Call me Win. This is my partner, June."

"Allow me to introduce my staff," Sheldon said. "Barbara you've already met. On her right is Charles Parr, also known as Chip. He's our agronomist. I've told you what that entails. Across from me is Doug Banner, my assistant designer and our resident artist. He did the murals in the front office, and he has done the color renderings of every course I've designed for the past ten years—including Skylark. His oil paintings based on Sheldon Moore designs have won prizes and have been exhibited in several art galleries. And next to Doug is Andy Putnam, also known as Putt, who designs our brochures and does a bunch of computer stuff that nobody else understands, but he has us convinced we need him."

An uneasy chuckle rippled around the room and stopped at Putt, who sat muffin-faced.

"Okay," Sheldon continued. "It's Monday. As you all know, our customer is arriving on Thursday. On Thursday afternoon I expect to have that design on this table. I don't need to tell you that if it's not on this table on Thursday afternoon, I'm in serious

trouble, this company's in serious trouble, and so are your next paychecks. Okay? So I want you to cooperate completely with Win and June. Whenever they want to talk to you, you drop everything and talk to them. When they ask you questions, you answer, and you tell the truth. Our policy of company confidentiality extends to them. You can, in fact you must, tell them whatever you know. Okay?" Sheldon paused and repeated, "Okay?"

Barbara and the men nodded and mumbled their agreement.

Sheldon said, "Win, June, do you folks have anything to say at this time?"

Win looked around at the staff and said, "Who here plays golf?"

Barbara and Chip both raised their hands.

"Great," Win said, smiling. "Me too. I'll talk to you two this afternoon, and June can talk to Putt and Doug." He turned to Sheldon and said, "This is the whole staff?"

Sheldon nodded.

June asked, "How about the person out front? Selia, is it?"

Sheldon shook his head. "You don't need to question her."

Win noticed a slight smirk flicker over Barbara's face. He said, "Well, just for the record, perhaps I'd better have a few words with her, too."

As if on cue, the door to the conference room opened and a delicious-looking young woman walked in, wearing an alarmingly brief miniskirt and a smile. "Excuse me, Mr. Moore," she said. "You wife is on the phone." Win noticed the glimmer of lust in Sheldon's eyes as he looked across the room at this exotic child.

"Selia, take a message," Barbara snapped. "I told you we weren't to be interrupted."

"I'm sorry, ma'am," Selia said, still smiling, then turned to Sheldon and said, "You wife is very urgent, she says."

Sheldon sighed, stood up, and walked over to the phone on a side table. He lifted the receiver and punched a blinking green light. "Carol, I'll call you back in five minutes. I...huh? Yeah,

okay. And tell the cook we've got two guests for dinner. Right. Bye." He hung up.

He nodded at the young woman, who drifted backwards, like a breeze, out the door.

"Well, I guess that wraps it up for now," Sheldon said. "Back to work everybody."

Back in his office, Sheldon sat behind his desk and June and Win again sat in the wing chairs. "Well," the architect said, "what do you think of my staff?"

"Okay for starters," Win said. "We'll tell you more after we've had a chance to chat with each of them."

"Fine. I'm sure they'll cooperate, since their jobs are on the line. Of course there's one problem," Sheldon said.

"Oh?"

"One of them won't be telling the truth. I hope you two are free for dinner this evening," he continued. "I want you to come to my house, meet my wife, go over what you find out this afternoon."

"Sounds good," June replied.

"Barbara will give you directions. Come at seven. Barbara will also make hotel reservations for you in Carmel. You brought enough clothes for a couple of days?"

"We're all set," Win said.

"Any questions?"

"Not at this point," Win said.

"I have one," June said. "This Selia person. Is she a golfer?"

Sheldon laughed out loud. "Selia? Hell no. She's got her talents, but...."

"Well in that case," June said, smiling sweetly, "I think I should be the one to chat her up. Is that okay with you, Win?"

Win was only slightly disappointed. "She's all yours, partner," he said.

Doug's Handicap

June knocked gently on the open door before stepping down into the office of the assistant designer. Doug smiled at her from behind his desk and started to rise, but she told him, "Don't get up. Is this a good time for us to chat?"

"Of course," Doug said. "You heard the man. I'm at your disposal, whenever. Have a seat." He sat calmly behind the desk, his hands folded. He was a nice-looking middle-aged man with a sensible, friendly face.

This office had obviously been a family room at one time. It was on a sunken level, and the ceiling boasted a large skylight that flooded the room with natural light. Doug's desk was in the center of the room, cluttered with coffee cans full of drawing tools, and against each wall stood a drawing board with work in progress. The walls were covered in cork, and the cork was covered with sketches and drawings.

June sat on one of the visitor's chairs and said, "I love the murals in the front office. Are those all golf courses Sheldon designed?"

Doug's smile faded as he answered, "They're all Sheldon R Moore the Third designs, if that's what you're asking."

"Meaning he didn't do the actual designing?" June asked.

Doug took his time answering. "Sheldon's a great idea man," he finally said. "And a great salesman."

"And as a designer?" June probed. "Remember, he wants you to be honest with Win and me. And everything you say is in strict confidence. I won't tell Sheldon what you said, and I won't tell the world either. So, let's have it: Sheldon doesn't really design courses, does he? You do. Right?"

Doug nodded. "Sheldon R Moore the Third couldn't design a game of tic-tac-toe," he said. "He trades on his father's name and my talent. I do the work, and he gets the credit. He also owns all

the rights to all my paintings of his golf courses as well as the colored renderings of his finished designs. How's that?"

"And how does that make you feel?" June asked.

Doug laughed. "You sound like a shrink."

"No, just your average lady gumshoe," June laughed back. "So how do you feel about your boss. Resentful?"

Doug picked up a pencil and drummed the desk. "Well, between you and me—who am I kidding, this office is probably bugged, but I don't care, because he knows it anyway—Sheldon R Moore the Third is the one person in all the world I'd gladly kill if I were a murderer. Which, alas, I'm not. I'd love nothing more than to expose him for the fraud he is, but that would bring this company to its knees, and my job with it. The truth is, I like my work in spite of Sheldon, and he pays me so damn well, I'm pretty much stuck with the situation. Which is why I hope this mystery gets solved before Thursday afternoon."

June smiled. "I'm with you. Let's find these plans together. Come on, Doug, spill. Who took them?"

"Hell if I know," Doug answered. "I wish I did know. All I know is I didn't take them."

"When did you last see them?" she asked.

"Wednesday afternoon. I asked Selia to bring them to me because I'd realized in the middle of the night before that I'd put in two hole sixes. I know that sounds crazy, but I sometimes letter these things upside down, depending on the position of the course, and I'd put an extra six where a nine should be."

"Okay, back to Wednesday afternoon. Selia brought you the plans, and you changed a six into a nine. Then what?"

"Well, as far as I was concerned that was it. The job was finished. Selia took the design to Putt."

"Why?"

"Putt's already started working on the brochure. Actually I don't know why Putt's doing a brochure on this one, since the job's commissioned and already financed. But who knows what

Putt does? That's a whole new school of design I know nothing about. Anyway Putt told Selia he needed the design."

"You don't use a computer in your designs?"

"Miss Jacobs, I'm an old-fashioned painter. I happen to love golf courses, and I love to paint. I also happen to be a good designer, but everything I learned about design I learned from Sheldon Moore, Jr. That's Sheldon's father, for whom I apprenticed, thirty years ago. I learned back when designers used X-acto knives and tissue paper, kneaded erasers, French curves, and pushpins. And I still do. Computers I don't do. I realize that's a handicap in today's market."

"Do you ever worry that you'll be replaced by a machine?" June asked.

"Not in this office," Doug replied. "Sheldon's a millionaire because of my talent. He's got Putt to make computer versions of my work, so they can be carried around in a disk or sent around the world by e-mail, but the actual design comes from this office. Putt knows that, and so does Sheldon."

"Well, if Putt has a computer version of the design, wouldn't that do for the sale? I realize you're proud of your work, but wouldn't a computer version satisfy the client, this sultan?"

"Sheldon told Putt not to scan this design. There is no computer version. No photocopy either. That original design is it. There's no copy."

"What about working drafts?" June asked.

"Shredded. You have no idea how paranoid this whole affair has been."

"Why is that?"

Doug shrugged. "Sheldon Moore is a strange man," he answered. "He gets stranger with every new design, but this one takes the cake."

"Where is the course going to be built?" June asked.

"That's the sixty-four-dollar question, Miss Jacobs. You tell me and we'll both know."

"But didn't you walk the ground? How did you know how the course would fit?"

"Sheldon gave me an aerial photo taken back sometime in the 1920s. He also gave me a land survey plot, with all of the identifying names removed—not just erased or covered over, I mean cut out entirely, like holes in the paper—and he gave me about a hundred Polaroid photos. That's it. For months those items were pinned all over these walls."

"And where are they now?"

"Shredded."

"So what you're saying," June said, "is you couldn't reconstruct this design?"

"You got it."

"Too bad."

"You're telling me. This place has been a tornado of accusations since late last Wednesday, when Sheldon discovered the design was missing. I'm afraid the company's going to fall apart, and I'll be out looking for a job, fifty-six years old, with no computer skills in my bag of tricks, and no golf game either."

"Don't worry, Doug," June assured him, as she stood up. "We're going to find that design."

"I hope you do," Doug answered. "I wish you luck."

June stopped at the door and turned back. "Doug, tell me one more thing. Why is it you don't play golf?"

Doug laughed. "Seems like a useless way to spend an afternoon," he answered. "I love golf courses. I walk on the Spanish Bay course every afternoon after work, just to clear my mind of all the tension. I try to time my walk to hear the daily march of the bagpiper, so I can stop hearing the voice of Sheldon Moore yelling in my head. All my life I've loved golf courses, and that's all I ever paint. But I've never tried to hit a little white ball around. Life has enough problems without that. I'd rather swing a paintbrush."

After June had left his office, Doug lifted the phone and dialed his home. When his wife, Mary, answered, he said, "Honey, do me a favor. Go in my studio and take the canvas I'm working on out to the garage. Wrap it in plastic for me, will you? Thank you, dear. See you later."

10 Chip Shots and Dirt

"So, Chip," Win asked, "what exactly does an agronomist do?"

"I do the dirty work," the young man replied. He pointed at a collection of stainless steel machinery filling one end of his office. "All that equipment is for soil analysis. That's what a golf course is when you take away the golfers and the grass: lots and lots of dirt, with some water here and there and some sand thrown in. But mainly it's dirt. Of course as an agronomist I'm supposed to call it soil. In fact, I almost got thrown out of ag school for using the word dirt. But let's face it, you're here to dig up dirt, and I'm willing to call a spade a spade and dirt dirt."

"And dirt's important?"

"You bet," Chip said. "What kind of dirt you have determines what kind of grasses will grow, what kind of trees to plant, how to irrigate, how to shape the fairways, how to build contours, you name it."

"Show me around your office," Win asked, "if you don't mind."

"Certainly," Chip said. "You're the first person in months to take any interest in what I do." He stood up from his desk and walked over to a library of books that covered one wall. "This section is on trees. Here we got weather. Soil on these two shelves; amazing how many books have been written about dirt, and I'm not just talking Kitty Kelley. Grasses. Ornamental landscaping.

And of course golf. I've got a whole library on golf."

"You like golf," Win observed. "Great game, huh?"

"World's craziest pastime," Chip said, with a wry smile. "The damn game drives me nuts, but it's got me hooked. Just like this job. This job has more bunkers than Death Valley, but I love it."

"And how do you like working for Sheldon Moore?" Win asked. "How do you rate him as a boss?"

Chip chuckled. "Triple bogey," he answered.

"That bad?"

"Unbelievable."

"That seems to be the consensus around here," Win remarked. "So, as long as we're talking about dirt, who do you think took the design? Anybody really have it in for Sheldon? Or is there anyone here that you don't trust?"

Chip led Win to another wall, another set of shelves. On these shelves were bottles and jars, all labeled. "Here's the dirt, right here," he said, fondling a jar with careful fingers. "I've been collecting these specimens for years. They're my best friends and my favorite possessions, and they're the only kind of dirt I know anything about. The rest is anybody's guess."

"So guess," Win prodded.

Chip sighed. "There's only one person here that I don't really trust. The rest are as honest as the rules of golf. Summer rules."

"And who's that one?"

"Sheldon R Moore the Third. I wouldn't believe his score-card if it were notarized."

Win laughed and the two men sat down. "When I first saw you, you were reading a book about ethical landscaping. What does that have to do with golf?"

"It's got everything to do with golf," Chip answered, passion in his voice. "Or it should. I happen to believe we should make golf courses agree with their environments, not clash and compete. The whole world doesn't have to look like the Masters, you know."

"And how does Sheldon feel about that?"

"He resists the idea, but I think I'm winning him over. For one thing it's cheaper to landscape in native plants. Use the existing soil and as much of the terrain as you can. Don't over-irrigate. Don't try to turn everything green, all year round. You can golf on brown grass just as well as you can on green."

"How about this new course, Skylark? Will that meet with your approval?"

"Yes," Chip admitted. "As far as I know. The plans are ecologically valid, if you don't mind sacrificing yet another wetlands to the game of golf."

"Do you know where this golf course is going to be built?" Win asked.

"Of course not. That's the most closely guarded secret in the world of golf. But I do know it'll be on the Pacific coast," Chip said. "Probably not far from here."

"How do you know that?"

"The soil samples Sheldon brought in give us the Pacific coast. And he collected them in the morning and brought them to me that afternoon. I believe him on that, because the dirt he brought in matched the dirt on his boots."

Win nodded with a grin. "You're not such a bad sleuth yourself," he said.

Chip grinned back. "It's amazing what you can learn from a little dirt."

"What about endangered species? Will Sheldon need to get an environmental impact report?"

"Of course. And a bunch of other permits, too. But Sheldon plays golf with half the board of supervisors and most of the planning commission. Done deal, he says. Endangered species aren't my department, really. But I'll tell you this: there's only one species Sheldon Moore gives a hoot about, and that's *Homo sapiens golfus maniac*. Actually," Chip added, "Skylark will be a pretty responsible course environmentally speaking. Doug's done a

good job of respecting the land. He's called for a burn through the course to drain the land, and he's pushing some dirt around, but no major insult."

"A burn?" Win asked. "That's not an insult?"

"Not a fire," Chip explained. "A burn is like an artificial creek."

"You obviously love your job," Win said. "Do you ever get out in the field?"

"That's my favorite part. Clomping around, digging in the dirt. That's why I don't really care that much about Skylark. No personal involvement. I just hope that design turns up soon and we can all get back to work."

"When's the last time you saw the design?" Win asked.

"Last Wednesday afternoon," Chip answered. "I'm not sure exactly what time. I asked Selia to bring it to me, and she got it from Putt. I wanted to have another look at Doug's burn. Then Selia took the plan to Barbara so it could be stored in Sheldon's locked closet."

"Did Selia hang around in this office while you were looking at the design?" Win asked.

"No, she told me she was going to the ladies' room to take off her pantyhose. Boy. That little chickadee's going to drive us all nuts. So, as you can see, I was alone with the design for about five minutes. That's what you wanted to know, right?"

After a cordial goodbye, Win left Chip's office. Chip picked up his phone and dialed 9 for an outside line, then punched a number he knew by heart.

"Hello?"

"Hi, it's Chip. I've met the detectives. This is not looking good at all."

11 Putt's Hard Drive

June walked down the hall toward the back of the building. At the end of the hall, on the right, she found what at one time must have been a bedroom. In fact, it still looked a bit like the bedroom of a young teenager, its curtains drawn and its walls covered with posters of superheroes and golfers. June knocked gently on the open door, and then, realizing the room was empty, walked in.

To say the room was empty would be a bit misleading. In fact the space was filled to capacity with four large desks arranged not quite at right angles. On each desk was a computer, and each computer was alive and humming, with kaleidoscopic screen savers dancing in colorful, silent explosions.

June sat down in front of one of the machines and moved the mouse. The screen saver vanished, and she beheld the fairway of a golf course stretched out before her. At the bottom of the screen rested a white dot, a golf ball. She touched the mouse again, and the computer bonged gently and a dialogue box appeared with the words, ADDRESS THE BALL

Okay, June thought, hitting ENTER

Suddenly the angle of her vision changed, and she was now looking down at the ball before her on the ground. Now what?

SELECT A CLUB

June went to the "Clubs" menu and picked the first one she saw when the menu dropped.

YOU ARE STILL 47 YARDS FROM THE CUP. ARE YOU SURE YOU WANT TO USE YOUR PUTTER FOR THIS SHOT?

Curiouser and curiouser, June thought. She hit "Return." A golf club appeared on her screen, along with a pair of hands, which were responsive to her mouse. She put the hands on the club, moved the club to the left side of the ball, and....

DO YOU WANT TO SWING LEFT-HANDED?

No. She put her club on the right side of the ball. That's better.

SWING?

ENTER. The club moved up out of view, then came flying forward. *Swish, Thwack!*

The fairway came back into view, with her golf ball fumbling forward a few feet. A voice from the computer said, "Too bad, Andy. You want to take that one over?"

A voice behind her said, "If I were you, I'd go home."

June spun around in the swivel chair and found herself facing the pudgy young man she'd met in the conference room, Andy Putnam. "Putt," Sheldon had called him. "Oh, I'm sorry," June said, standing up. "I hope I didn't mess things up for you. I was just so intrigued. What a neat game!"

"Have a seat," Putt said. He took a chair in front of another desk, then swiveled it around to face her. He didn't seem especially angry, even if he had suggested that she go home.

June sat back down and smiled. "That's a neat game," she repeated. "Where did you get it?"

The question appeared to disturb the young man. "Get it? What do you mean?"

"I mean, is this a game you can buy?"

"Not yet," Putt answered. "I'm still working on it. Still a few bugs."

"Oh, I see," June responded. "You invented this game. This is yours!"

Putt shrugged and grinned. "Yeah."

"What do you call it?" June asked.

"I don't know yet," Putt answered.

"Will you show me how it works?"

Putt rolled toward her in his chair and they both swiveled to face the screen. He said, "Go home."

June looked at the young man's face and found no hostility there. "I'm sorry, Andy. I don't mean to get in your way. I just want to ask you a few questions and then I'll leave you to your work. Okay?"

Putt's jaw dropped. "Hey," he said. "Chill. No problem, okay? All I meant was go back to the beginning of the game. See that box up at the top that says 'Home'? Click on that. And don't save changes; I don't want that last shot of yours on my scorecard."

Much relieved, June did as she was told. The screen turned entirely green and then slowly changed into a golf course map, dotted with greens. The ocean appeared on the left side, and a dark forest appeared on the right, and in between them was the golf course, shaped like the head of a pelican with its beak extending into the ocean. The line between its upper and lower jaws was formed by a river that started high in the course and extended all the way down and out to sea.

"This isn't the final home page," Putt told her. "Eventually the game will open with the clubhouse. But I haven't constructed the clubhouse yet."

"In the meantime," June said, "this is the overview of the game?"

"Yup."

"Is this based on a real course, or did you just make it up?"

"I made it up," Putt answered. "Sort of. Do you want to play a few holes?"

June said, "Not today, Andy. I'm supposed to meet my partner in a few minutes. But maybe you have time to answer a few questions?"

"Okay."

"One thing I need to know," she started, "is when's the last time you saw the missing design."

"Last Wednesday afternoon. I told Selia to get it for me so I could check on the position of some trees."

"Did you happen to notice what time that was?" June asked.

"No. Sometime in the middle of the afternoon. I only had the design for about fifteen minutes. Then Selia came and got it. She said Chip needed it for something."

"How do you like working here, Putt? Should I call you Putt,

by the way? Or do you prefer Andy?"

"Putt's cool. My boss made up the name. I don't care what he calls me, so long as he pays me."

"Do you like your job?"

"It's okay. There's not much money, but I get to spend all day playing with my toys." He waved his hands affectionately at his array of computer screens.

"Is Sheldon an easy boss to work for?"

Putt snickered. "He's like basically stupid. All he cares about is golf and money. He doesn't have any idea what I'm doing in here. But he knows that all the design firms need computer guys, so he leaves me alone."

"What exactly do you do, Putt?"

Putt shrugged. "Brochures and stuff. Doug won't let me do any real design work, but I've been making games out of all the Sheldon Moore courses. I also do spreadsheets and stuff for Chip for his soil analyses. But mostly they leave me alone."

"Have you done a brochure for this new one, the missing course?" June asked.

"That's what I'm working on now," Putt answered. "Here." He swung his chair around to face another computer and flicked the mouse. A PageMaker document came up on the screen, showing Sheldon R Moore III's smiling face on one panel, a photo of one of the greens on another, and a letter from Sheldon on a third, under a blank square.

"What's on the other side?" June asked.

"A map of the course," Putt answered.

"May I see it?"

"Uh…it's still under construction."

Sensing his discomfort, she said, "That's okay. How about that blank square? What goes in there?"

"That'll be the clubhouse," Putt explained. "But we don't have any graphics for that yet."

"Is it an existing building?" June asked. "Or will it have to be

built?"

"Nobody knows. Which is so stupid. I don't know how Sheldon expects me to design a brochure without telling me the details. But that's what bosses do. I just do my job."

"And play computer games," June added. "Right?"

"Whatever. Hey, I've got to stay busy."

After June had left the office, Andy sat down in front of another of his computers and double-clicked on Netscape Navigator. The modem whirred and buzzed and connected, and Yahoo presented itself. Andy typed, "slugfest.kaizen.net/" and hit return, then drummed his fingers impatiently until his favorite game had downloaded.

Celebrity Slugfest. It was a boxing match between the user and a whole menu of opponents, from Ted Kennedy to Rush Limbaugh, from Madonna to O.J. Simpson.

Andy Putnam hummed a happy tune of revenge as he selected the smiling face of the world's most famous golf course architect, then grunted with satisfied rage as he beat his boss's face to a bloody pulp.

 ## Barbara's Backswing

Win and June arrived at the outer office at the same time. Barbara was not at her desk, and so they sat down to wait in chairs that had been positioned against one of Doug's painted walls, feeling as if they were on the terrace of a country club looking out over vast fairways in all directions.

"Well?" Win asked. "Have you learned anything important?"

"Maybe," June answered. "How about you?"

Before Win could answer, Barbara Sutton came out of Shel-

don's office, closing the door behind her. She smiled efficiently at the investigators and took a seat behind her desk. "So," she said. "How's it going? Have you found our design yet?"

"We're hot on the trail," Win said. "I'd like a few words with you, and June wants to ask Selia a few questions. Then we'll have a talk with Sheldon."

Barbara shook her head. "Selia and Sheldon have both left for the day," she said. "But you'll be seeing Sheldon tonight. You're going to his home for dinner."

"Right," Win said. "And we'll see Selia tomorrow. In the meantime, may we ask you some questions?"

"Of course. That's why you're here, right? Let's get it over with."

This lady needs to polish her people skills, Win thought. From his experience as a police detective, he knew the right approach was to butter her up a bit. "Well," he began, "Barbara, I'm glad we caught you before you went home, because you're probably the most important person for us to talk to."

"Oh? Why's that? You don't think I took the design, do you?"

"No, of course not," Win assured her. "It's just that you no doubt know more about what goes on around here than anybody else. Secretaries are the nerve center of any small business."

Barbara stood up behind her desk and leaned forward onto her fists. "Now you listen to me, Mr. Winslow. You too, Ms. Jacobs. I realize Sheldon Moore calls me his secretary, so that's an honest, if sexist, mistake. But I want you to start knowing, right now, that I am *not* a secretary. That is not my job description. I am the business manager of Sheldon R Moore Golf Course Designs. I do accounts receivable and accounts payable. I do payroll and the general ledger. I deal with every level of government, from the city council to the IRS. I keep track of inventory and supplies. I'm also in charge of personnel benefits and I hold the hands of upset employees, which is a frequent issue around here. I also, from time to time, answer the phones and occasionally I

even take dictation, but I am not a secretary. As far as my knowing everything that happens around here, I don't know any more than your average know-it-all busybody, which I admit I am. But I have no idea whatsoever where that god damn design is. And if Sheldon Moore was too paranoid to have a backup copy, then it's not my problem, is it." She sat back down and sighed heavily. "The tension level has been high lately, as you can imagine. And you're right: Sheldon treats me like a secretary, meaning it's my fault when something gets lost. Sorry for the outburst."

"*We're* sorry," June was quick to reply. "And I'm glad you set us straight about your role in this business."

Win took a moment to recover, then said, "What we're trying to establish, June and I, is the path that the design followed on Wednesday afternoon. By the end of the afternoon it was lost, right?"

"That's right," Barbara said. "At the end of the day I went to lock the design in Sheldon's closet, as usual, but I couldn't find it anywhere. Nobody in the office knew where it was."

"And the last time you saw it?" June asked. "When was that?"

"I gave the design to Selia and asked her to take it to Doug. He had buzzed me and asked for it."

"What time was that exactly?" Win asked.

"Midafternoon. I didn't notice the time."

"Okay," June concluded. "The design went from you to Doug. According to Doug, he then sent it to Andy, who sent it on to Chip."

"That's right," Win said. "Chip told me he got it from Putt. After he was through with it, Chip sent it to Barbara."

"That's true," Barbara said. "Selia did bring me the design from Chip, but that was *before* I sent it to Doug."

"And each member of the staff claimed to have seen the darn thing only once," Win said. "We're in a loop. Obviously somebody's not telling us the whole truth. Well, maybe we'll find out something from Selia tomorrow. She was the one who connected

all these stops."

"If Selia remembers," Barbara added. "She tends to forget things."

"Do you think she'd conceal information?" June asked.

"No. I just think she's an airhead. I *know* she's an airhead."

"Then what's she doing working for this firm?" Win asked.

Barbara smiled sourly. "I didn't hire her," she snapped. "Sheldon Moore hired her. You figure it out."

"One other question," Win said. "Then we'll get out of your hair. June and I are puzzled about motive here. There hasn't been any ransom note, and of course nobody could fence the design at a swap meet. So it seems to us that the motive had to be something like revenge, or a personal grudge."

Barbara nodded but didn't volunteer any thoughts on the subject.

June asked her, "Does Sheldon have any enemies? Anybody outside the business who would wish him ill?"

Barbara laughed. "Sheldon has plenty of enemies. But none of them were in the building on Wednesday afternoon."

"What kind of enemies?" Win pressed. "Can you name a few?"

"Martin and Millie Ramsey, for starters," Barbara said. "They're environmental nuts. Cranks. I keep expecting them to throw a brick through one of our windows. But they weren't here on Wednesday."

"Anyone else you can think of?"

"Well, Sheldon has this feud going with Greg Perry, another designer. But he wasn't here on Wednesday either. Nobody was. I told you that."

"Well, think it over, Barbara. If anything occurs to you, we'll be back tomorrow. In the meantime, thanks for being so cooperative."

Barbara opened a manila folder on her desk and said, "Here, let me give you a security pass."

June and Win walked over to her desk and Barbara gave Win a bright plastic card. "It's good for as long as you'll be here. It'll save you a lot of nuisance coming in and out of the forest. Which gate did you come through today?"

"Carmel," Win said.

"Good. You'll be staying in Carmel. I've made reservations for you at Svendsgaard's Inn. As for tonight, you'll come back through the Carmel Gate and take Seventeen Mile Drive on past the office here for another 1.4 miles. The Moores' place is called Pelican's Nest. You'll see the driveway on your left. It's marked by a large stone pelican."

"Sounds easy to find," June said.

Barbara said, "It's not."

"We'll find it," Win said. "What time?"

"Be there at seven-thirty, sharp, for cocktails," Barbara instructed them. "I'd be on time if I were you. The butler is very fussy and he'll let you know if you're a minute late."

"My oh my," June said, grinning. "A butler, yet."

"Oh yes," Barbara said. "Their house reeks with class. The driveway is half a mile long, ending in a large parking area before the six-car garage. Then there's a bit of a hike, about a hundred feet, to the front door. Don't get misled by the servants' entrance. James will be watching for you."

"James?"

"The lord high butler," Barbara said. "You'll recognize him by the white gloves."

"You don't sound all that fond of the help," Win noticed.

"Oh, James is all right, I guess. He's awfully protective of his master, of whom I'm very fond. James doesn't like for me to visit him. Says I get him too excited."

June's eyes opened wide. "You mean Sheldon Moore? Don't you get to see him every day anyway?"

Barbara laughed. It was the first time Win had seen her relax that face of hers. "Oh my God, no. I mean the real lord of the

manor, Jonathan Wise. That's Sheldon's wife's uncle. He's a dear old man. It's his estate, really. Sheldon and Carol just live there."

"Will we meet him tonight?" June asked.

"If he's feeling social," Barbara answered. "And if James lets him out of his cage."

After the front door of the design firm closed and Barbara could hear Win and June getting into their car, she lifted her telephone and buzzed Sheldon's inner office. When Selia answered, Barbara told her, "Tell Mr. Moore they've gone. You can come out now."

 ## Playing a Round Before Dinner

Getting to the motel was not as easy as June expected it to be. The late-afternoon traffic, even on a Monday in October, was jam-packed with tourists moving as slowly as they could get away with, squeezing their money's worth out of the cost of driving on Seventeen Mile Drive. Win eased the Tracer into the parade and they poked along with the herd, blocked by turtle-paced tourists in front of them, tailgated by impatient residents behind.

When they finally reached the Carmel Gate, the guard waved them out and they entered the even slower traffic of Ocean Avenue dividing downtown Carmel. They passed the green-and-white Pine Inn and turned left on San Carlos Avenue. They found Svendsgaard's inn and pulled into the parking lot.

Win killed the engine, then sat with his hands gripping the steering wheel. June studied the profile of his face, noticing the muscles in his jaw hard at work.

"You're solving the case, aren't you," she observed. "Anything you want to share with me?"

"Nobody seems to like our client very much," Win said. "And I have to say I feel the same way."

"He's a first-class jerk," June agreed. "I could have told you that. In fact I did tell you that." She regretted that remark. One secret of a successful love affair is never to say "I told you so."

For that matter, June was tired of this case already. At least for the afternoon. She wanted to forget about Sheldon R Moore III and concentrate on that successful love affair. After all, how often did a couple in love get a chance to spend a few days in Carmel, all expenses paid?

But she couldn't let the subject drop. Win was clearly obsessed with this case, and she had to support him. "So tell me what you're thinking. What's your take on the first-class jerk?"

Win turned to her and said, "Well, I'm teed off, frankly. He's a manipulator."

"I agree with you there."

"I mean, the guy got us down here with a promise he didn't keep. Well, maybe he didn't promise it exactly, but he led me to believe I'd be playing golf at Pebble Beach this afternoon. Not that I don't want to work, of course, but it's pretty clear that Sheldon never did intend to get out on the golf course with me."

Golfers. June would never understand them.

She put her hand on her lover's knee and said, "Soften that brow, sweetheart. Let's see if we can find another course for you to play a round on."

Win unpacked while June surveyed their room. It was charming, with two comfortable armchairs, a white armoire that housed a minibar and a television, and a round maple table with a welcoming bowl of apples. The bathroom had cupids on the wallpaper and a basket full of fancy soaps. The bed was a giant four-poster with a striped cotton canopy. The comforter was a rich green field, with skirts in a Laura Ashley floral design.

"Not bad," June said. She stood for a moment looking out the

picture window, which framed willowy trees, a bit of the village, and the Pacific Ocean in the distance. "What a lovely view," she said, as if it had to be said at least once. Then she promptly tugged on the cord and pulled the heavy curtains closed, canceling the trees, the village, and the ocean, darkening the room to a soft twilight glow. She turned around slowly and gazed across at her golfing sleuth, who was pulling his shirt over his head.

"What a lovely sight indeed," she murmured, as his furry, well-muscled chest came into view. She walked forward and put her hands on Win's shoulders. He returned her gaze, a goofy grin growing on his face.

"I was about to try out the shower," he mumbled, "unless...."

Her fingertips traced a line down his belly and settled on his belt buckle. "I think we ought to check out the rub of the green first," she said softly.

"Mmm," he responded. "I love it when you talk golf."

"So I see. Is this a driver?"

"One-wood."

"Feels like titanium. Will you show me how to use it?"

Clothing dropped to the floor as the lovers landed on the green comforter with a soft bounce and throaty laugh.

"Ahh," sighed June. "Oh yes. Give me a lesson in that."

"You catch on fast," Win responded, his breath quickening.

"You're a good teacher. What's this called?"

"This is the rough."

"And this?"

"The fringe."

"And this?"

"I'd call that a gimme."

"Yes. Call it that. Be my guest."

"Lovely."

"How's my grip?"

"Excellent."

"And my swing?"

"Your swing is divine. The secret of golf?"

"Yes?"

"Is to concentrate…."

"On?"

"On not concentrating. Head down, follow through…."

"Head down, follow through…."

"Shhh…."

Win awoke from his nap and found June smiling across the pillow at him, just inches from his face. He stroked her shoulder and pulled her to a kiss.

"You're beautiful," he told her.

"Mmm," she agreed. "I know. And so are you."

"How do you feel? Par for the course?"

"Better than that. I shot a double eagle."

"That's very rare," he told her.

"I used to think so," June said. "But it happens a lot when I play with you."

 Jonathan's Wedge

There was just enough light left in the sky to make the forest on either side of Seventeen Mile Drive seem all the darker. Win kept an eye on the odometer, and when they'd gone a mile past the center of Pebble Beach he slowed down.

"There it is," June said a minute later. "Up there on the left."

As Barbara had promised, there stood a stone pelican, survey-ing the road. Perched on a post, the giant bird was six feet off the ground, with a comical expression that seemed to resent Win's

headlights in its eyes.

Win turned the Tracer into the otherwise unmarked drive, and they carried on for half a mile, through woods that were pitch black all around them. Win felt June's hand tighten on his thigh. "Spooky," he agreed.

Finally, they saw a light, which became larger and brighter as they wound down to the courtyard of what looked like an English manor house. They parked in front of a long garage and got out into the nippy night air, which smelled of wood smoke. The soft hoot of a horned owl called out of the forest.

Hand in hand, Win and June walked along the pathway to a brick arch, where another pathway led them to the main entrance of the mansion. The doorway was well lit with twin carriage lanterns. Win lifted the heavy brass knocker and let it fall against the plate on the oak door. Almost immediately they heard footsteps within, and the door swung open.

There stood Sheldon R Moore III, nattily dressed in blue blazer and gray slacks, beaming at them with an outstretched hand. "Right on time," he said heartily. "Come in, come in!"

They followed their host into the foyer, where a full suit of armor stood at attention. "Allow me to introduce my mother-in-law," Sheldon boomed. "She's an old battle-axe, as you can see."

Win bowed politely to the armor, noticing that June hadn't smiled at Sheldon's joke. Then they followed Sheldon into the front hall of the mansion, where a slim, petite woman in a silver-gray jumpsuit was gracefully descending a curving staircase. Sheldon took her by the hand and said, "This is my wife, Carol. Carol, meet Harry Winslow and June Jacobs."

Carol Moore smiled shyly and said, "Welcome, Mr. Winslow. Welcome, Ms. Jacobs. I'm delighted to meet you. It's so good to have company. Please. Come into the living room."

She led the way through an arched doorway and down a few steps into a room handsomely furnished in silk, chenille, and leather. The two couples took seats on facing sofas, a coffee table

between them.

"What a nice room, Mrs. Moore," June commented. "And a lovely house. Thank you for having us on such short notice."

"Thank you, June," Carol replied. "And please call me Carol. I really am delighted to have you here. We entertain so seldom."

Win guessed that remark was aimed at her husband, who fidgeted a bit before adding, "Our social life mostly takes place on the golf course."

"Yours does," Carol said, turning to her husband with a polite smile.

"So would yours, if you played golf," he snapped. "I think it's time we had cocktails."

As if on cue, a male servant appeared, a tall, serious man with a close-cropped white beard, dressed in white tie, white gloves, and tails. With a slight bow from the waist, he said, "May I bring you something to drink?" Beginning with June, he said, "Madam?"

"Gin and tonic, I guess."

"Scotch, please. On the rocks." Win said.

"Same here. On the rocks," Sheldon echoed.

"James," Carol said, "I would love some champagne."

"Certainly, madam."

"Oh brother," Sheldon chortled. "Look out. When my wife gets started on champagne…."

"Oh, be quiet," she said with a laugh that was a little less than a laugh. "June, will you join me?"

June said, "Of course. I love champagne."

"Very good," James concluded. "Champagne for the ladies, scotch for the gentlemen…."

"And a double brandy and soda for me," came a scratchy shout from across the room. Win looked up to see a small elderly man in the doorway. The old gent wore a smoking jacket and slippers, and was carefully negotiating the steps down into the living room with the aid of a cane.

"Uncle Jonathan!" Carol exclaimed. "How nice of you to join us. Come meet our guests."

Uncle Jonathan started shuffling his way across the Oriental carpet, his eyes glittering under bushy brows, his face split by a wide, eager grin.

"Here's the real reason we don't do that much entertaining," Sheldon whispered across the coffee table. To his wife, he muttered, "I thought you said he wouldn't be down tonight."

By the time the old man reached them, June and Win were on their feet to be introduced. Uncle Jonathan shouted, "Sit down! Tell me your names. James, bring me that chair."

James brought the old man a wooden armchair, helped him get settled, then left the room.

The old man grinned through all the introductions, then said, "I was hoping you'd bring that Barbara girl with you."

"Barbara?" Win asked.

"Uncle Jonathan has a crush on Sheldon's assistant," Carol Moore explained.

"She's a dish," Uncle Jonathan cackled. "And she brings me candy. What more could I ask for? At my age, that is."

James returned with a silver tray of drinks in one hand, a champagne cooler in the other. He placed the cooler on the coffee table and distributed the cocktails. Then he poured two glasses of champagne.

This is real elegance, Win thought. White gloves and all.

Uncle Jonathan held his glass up to the light and said, "You call this a double?"

James bowed and left.

"I envy you so much," June said to Carol and Sheldon. "To live in the heart of a forest. That's so romantic."

"Hell, this isn't the heart of the forest," Uncle Jonathan said. "We're on the edge. The edge of the world! Show them, Carol."

"Well, Uncle, it's after dark...."

"Show them!"

"Very well. Let's go out on the terrace." Carol and Sheldon stood up, and Win and June joined them. Uncle Jonathan struggled to his feet also, using his cane, which Win now noticed wasn't really a cane but a golf club. The old man gripped it by the sole and pulled himself slowly to his feet.

The group carried their drinks out of the living room onto a flagstone terrace, where Sheldon switched on a bank of floodlights. The Moores' lawn stretched out for about fifty yards and ended at what appeared to be a gently rolling meadow that went on forever out into the dark, as far as the lights would allow them to see.

"Lovely," June exclaimed. The horned owl still called in the chilly night.

"It goes all the way down to the ocean," Sheldon said. "Nice piece of earth. Completely undeveloped."

Uncle Jonathan rapped his golf club on the terrace. "And that's the way it's going to stay," he barked. "God damn it. You hear me?"

"Yes, Uncle," Sheldon sighed. "A million times."

"This land has been in my family since before I was born, God damn it!"

"Still is, Uncle, still is." Sheldon turned to his wife and said, "Carol, did you hear from...."

"Gonna stay that way!" The old man's voice had risen to a shout, and after his jaw snapped shut his words echoed, then faded in the night. The owl had stopped. "And some day it will belong to you—Carol," he added, turning to face his niece. "All yours."

"I'm glad California is a community property state," Sheldon joked.

"Excuse me, madam," came the voice of the butler, who stood in the doorway. "Dinner is served."

"Wonderful," Carol said. "Thank you, James. Shall we?" She took her husband's arm and led the procession back into the

house.

Win walked slowly, beside Uncle Jonathan. "That's a handsome walking stick you've got there," he offered. "What is it, a sand wedge?"

The old man cackled. "Sandwich. That's what I call it. My sandwich. I'm the Earl of Sandwich."

"Well, Earl, I can see you've never played golf with that sandwich of yours," Win observed. "You're a left-handed man, and that's a right-handed club."

"Hah! You're pretty sharp. This is my niece's club."

"I thought she didn't play golf."

"She doesn't. Me either. Can't stand it. Never tried it. Waste of time."

"Well, you must be getting some exercise. What do you do to stay so young?"

Uncle Jonathan raised his bushy eyebrows at Win and said, "Here, hold my sandwich." He handed the club to Win, then reached into the inner pocket of his smoking jacket and took out a flask. Using his teeth, he uncorked the flask and poured a healthy dose into his cocktail glass. "Chemistry," he said. "That's what keeps me in shape, son." Then he added, "That James is a fine fellow. He'll do anything for me except make me a decent brandy and soda. What did you say your name was?

"Win."

"Good choice. You're going to need a name like that if you're working for my nephew. Nephew-*in-law*."

🚩 15 The Main Course

James served consomme with the dignity of a monk. Carol lifted her spoon and the meal began. Uncle Jonathan slurped his consomme noisily, while Sheldon lifted his bowl and gulped like a hungry ranch hand.

June had the feeling that Sheldon's questionable table manners were intentional, an act designed to remind his family and his guests that he was very much in charge, in spite of the aristocratic formality of the dinner service and the dour ancestral portraits on the walls. He was a complex man, June decided, with enough brash power and overbearing charm to make him a brilliant salesman, and enough paranoid insecurity to rot an army.

Time spent with Sheldon R Moore III ticked like a bomb.

Well, June thought, at least we've eaten well on this trip so far. The dinner was delicious: roast beef, popovers, and asparagus, served with a Petite Sirah from a Monterey County vineyard.

"So, June," Carol said, "tell me. What do you and Win do?"

"They're consultants," Sheldon broke in. "They're here to help me make some decisions about a golf course project. Right, Win?"

"Sounds good to me," Win answered.

June had been interrupted and ignored once too often. She turned to Carol. "Do you want to hear about the case?" she offered.

"Carol does not take an interest in my business," Sheldon said. "We came to that agreement years ago, and that's the secret of our marriage."

Ye gods. "That, and not playing golf together," June added, smiling sweetly.

"I tried to get her interested in golf," Sheldon said. "Bought her a set of clubs, titaniums just like mine, graphite driver, the whole nine yards, scheduled lessons with golf pros all over the

Peninsula, agreed to play nine holes with her once a week...." He waved his fork slowly, as if conducting. "She's just not a golfer. What can I say?"

Carol brought her napkin to her lips and said, "Well, I have plenty to keep me busy. I'm involved with the Monterey Peninsula Nurses' Aid Society, the Boys' and Girls' Clubs of Monterey. Not to mention managing this house and taking care of Uncle Jonathan."

"I can take care of myself," the old man said from his end of the table.

"Of course you can, Uncle."

"Always have!"

"Of course. Anyway, I don't seem to have the time or the temperament for golf. Do you golf, June? I suppose you must, if you're here as a consultant on a golf course."

"Actually, I don't. Win's the golfer in our business. I'm the brains."

Uncle Jonathan laughed out loud, then coughed even louder.

James cleared the table and brought finger bowls.

Win said, "I'd be interested to hear the history of this house. I gather it's really your house, Mr. Wise?"

"Damn right. My land, too. My niece and her husband are welcome to live here, free of charge, but it's my house and I can take care of myself. James!" he shouted.

The butler appeared and said softly, "Yes, sir?"

"Take away these stupid finger bowls and bring us some dessert."

"Very good, sir."

Uncle Jonathan pointed at one of the portraits, a painting of a stern old gent with mutton chop whiskers. "My grandfather came out here right after the Civil War. Came here by sea and landed right on Pelican Point. Saw the meadows all fluttering with butterflies, all dotted white with egrets, and fell in love with it.

Bought it for a song. Our family's been here ever since, and we haven't changed a thing except to build this house. Oliver Ramsey and I built it ourselves, one damn board at a time."

"Ramsey," June said. "I've heard that name before."

"Oh, God," Sheldon groaned. "Let's don't start talking about the Ramseys."

Uncle Jonathan flared his nostrils and bounced his eyebrows. "You listen to me, sonny. Any member of the Ramsey family is welcome to walk on my property as long as I live. Is that clear?"

Sheldon shrugged like a football tackle. "Well. That won't be forever."

"James!"

The butler appeared. "Yes, Mr. Jonathan?"

"Help me up the stairs," the old man ordered, rising to his feet with the help of his sand wedge. James put his gloved hand under Jonathan's left elbow and escorted him across the dining room. When they reached the doorway, Jonathan turned back, and said with glittering eyes, "I'll outlive you, Sheldon Moore. I swear to God I will."

 Not a Game for Ladies

Dessert was a delicious chocolate soufflé, after which James served coffee. Not a word had been spoken from the time Uncle Jonathan stormed out until James cleared away the demitasse cups.

"Well," Win said when the meal was clearly over. "This has been lovely. A fine dinner, Carol, thank you so much."

"Our pleasure," responded the hostess. "I'm sorry for the fireworks."

"We're used to fireworks," June assured her. "And firearms."

Sheldon said, "Now, dear, if you'll excuse us, I need to spend some time with my consultants. You go on to bed. I won't be upstairs for another couple of hours at least."

Carol, obviously miffed by being so quickly dismissed, stood up from the table. "Please excuse me," she told Win and June. "It appears I have other things to attend to."

June and Win stood and shook her hand, then watched her leave the room without another glance at her husband.

Sheldon stood and said, "Come with me, you two." They followed him out of the dining room and down a hallway to an oak-paneled library with leather furniture and a rich Oriental carpet. A fire crackled in the fireplace, and above the mantel was a framed antique map of a shoreline.

Sheldon shut the door and said, "Sit down." He went over to a cabinet and pulled out a bottle. "Brandy?"

"No thank you," Win said.

"Sure," June said.

Sheldon poured a stiff drink for himself and a delicate snifter for June, then sat facing the investigators. "Well," he said, "what did you find out this afternoon? Any leads?"

"Too early to say," Win answered.

"It's Doug," Sheldon said sharply. "I know he's got the design. That bastard has hated me for years." He drank his brandy quickly.

"Well, if you know who's got the design," June asked, "why do you need us? Besides, I had a nice talk with him, and he doesn't seem like the kind of man who'd steal anything."

"Oh, sure," Sheldon grumbled. "Everybody loves Doug. Well, maybe he didn't do it, but I'm betting on him. Your job will be to prove it. And fast. I want that design on my desk by Thursday noon, or you two don't get paid."

"Hold on, Sheldon," Win said with an easy chuckle. "That's not in our contract. We're paid by the hour, not by the results. We're not billing you for this evening, by the way, but if you want

to go over the case again, as far as we've taken it...."

Sheldon consulted his watch. "Actually, I have another appointment," he said. "Let's talk tomorrow morning. Meet me at the Carmel beach pavilion at nine A.M. sharp. Sound good?" He rose to his feet.

"Fine," Win said, as he and June stood up.

"I can let you out this way," Sheldon said, opening a door on the far wall of the library. "Short cut."

Before leaving the room, June placed her unfinished brandy on the mantelpiece and took a closer look at the map. "Pelican Point," she read. "So this is your land."

"My *wife's uncle's* land," Sheldon Moore corrected her. "The largest remaining undeveloped open space in Pebble Beach, stomping ground to a million monarch butterflies, a few dozen egrets, and a bunch of banner-waving trespassers.

"Let's go." He flicked on some lights and led them through the door into a huge garage. Like a tour guide, he pointed out the autos as they walked by: "Uncle's Rolls, which only James is allowed to drive; Uncle's nurse's Honda; the cook's VW; Carol's Mercedes; James's Chevrolet; and, ta-da, my little Porsche." He pressed a button on the wall beside his Porsche, and a door slid up and let in the night. Win's Tracer awaited them outside.

"I see you're ready for action," Win observed, pointing at the two matching golf bags leaning side-by-side against the wall.

"Yeah," Sheldon said. "His and hers. Except that hers never gets used."

The Drive Out

Driving out through the forest to Seventeen Mile Drive, Win said, "He's right behind us."

"I swear that man is going to drive me nuts," June said. "I think Uncle Jonathan's right: he *will* outlive Sheldon Moore."

"Oh?"

"Yep. If Sheldon doesn't die of a stroke—which he deserves, by the way—I know of half a dozen people who wouldn't mind murdering the man. And if any of them needs any help, I'll be glad to offer them some technical assistance."

"Not fond of our client, are you?" Win teased.

June snorted. "What do you think of him?"

"Well, for one thing, he's a tailgater. Good, here's the road." Win turned right onto Seventeen Mile Drive. In the rearview mirror he could see Sheldon's tail lights hurry off in the direction of Pacific Grove. "Wonder where he's going at this time of night?" he said.

"Three guesses," June quipped. "His wife thinks he's in the library with us. Win?"

"Hmm?"

"I've seen that shape before."

"What shape?"

"Pelican Point."

 Forward Press

Shortly after midnight, Sheldon Moore drove his Porsche through the Country Club Gate and entered the Del Monte Forest. He was slightly drunk, happily exhausted, sexually spent, and thoroughly satisfied with himself. Trust his sweet Selia to make him feel like a man again.

Buying Selia that house in Pacific Grove was one of the smartest things he'd ever done, Sheldon mused. It laundered and sheltered some of the money he'd been paid by the sultan, it gave

Sheldon a nearby getaway for late-night liaisons when home life got too tense or too boring, and it kept Selia in her place—both grateful and available.

As he sped along Forest Lodge Road, he grinned with confidence and schemes. He was better than his father had ever been: richer, more famous, more golf courses to his credit, more women in his recent memory than his father had had all his life. Sheldon R Moore the *Third*. *Three's a charm*, Sheldon thought. *I've got it made*. In three days, the deal with the sultan would be concluded. Sheldon would be another ten million dollars richer, and he'd be free to start burning his bridges.

Only one problem stood in his way, the small matter of a missing golf course design, without which....

The hell with that, Sheldon thought. *I'm not going to start worrying about that now. That god damn problem's been chasing me like a pack of wolves in a nightmare. Their bright eyes burning in the night, blazing in my....*

That's when Sheldon realized that he was being followed. His rearview mirror was filled with the glare of high beams getting closer and closer, brighter and brighter in his eyes. Sheldon tried slowing down and driving over on the right shoulder of the road, but his pursuer stayed right with him, tailgating him by only a few yards.

Sheldon floored it. He knew the territory, he was driving a Porsche, he had it made. He sped off into the forest, driving far faster than even a sober man would do in the daylight on a much straighter road. He squealed around sharp curves, swerving from side to side, so that occasionally the headlights behind him disappeared briefly.

But only briefly. They returned, over and over, and they were gaining on him again.

Cypress trees dangled their clawlike branches, their trunks seeming to writhe in torture. Like torn strips of black crepe, moss hung loose from live Spanish oaks, casting ghastly shadows.

Sheldon skated around a curve on two wheels, only to slam on the brakes to avoid hitting a big-eyed doe that was crossing the road. The doe bounded into the inky forest as Sheldon spun through, fishtailing till he could regain control, choke down his adrenalin, and carry on, his attention flicking back and forth between the dark road ahead and the blazing eyes of the wolf on his tail.

Who the hell?

He split from Seventeen Mile Drive and zigzagged fiercely onto Wildcat Canyon Road, whipping through the blacked-out Spyglass Woods neighborhood. He veered back across the Drive, shot left and tore up Colton. He wove along Lookout Road, sped down Forest Way to Lopez and uphill again, past the dark Poppy Hills Golf Course, to Sunridge and the darkest and highest part of the forest, Huckleberry Hill.

Although it had been ten years since the area had burned to the ground, and new trees had risen in place of the dead ones, Huckleberry Hill still looked in the dark like a convention of skeletons, taunting the living.

And still the silent headlights behind him, daring him to die.

Could be anyone. Any one of them.

He raced downhill, chancing the twists and turns of Ronda Road. He streaked up Oleada and screeched down Forest Lake Road. The lights were right behind him.

He floored it along Drake Road, heading toward Cypress Point. His rearview mirror was ablaze.

He swung onto Sombria, dodged down Madre and, tires squealing, pulled a U-turn and dashed to Padre. Staying on this road, he know, would bring him to Alva and deliver him into the very heart of Pebble Beach, where there were sure to be lights, people, safety.

He made it. He roared into the Pebble Beach commercial center and pulled into the parking lot by his office, killed his engine, and turned off his headlights and climbed out of his Porsche.

The pursuer was nowhere to be seen.

He took a deep breath, then another. Another.

Suddenly he was assaulted in the eyes with another bright beam of light. He went into a crouch on the parking lot pavement.

"Mr. Moore?" said a friendly voice with an Irish accent. "Is that you?"

Sheldon untied, then retied his shoe. He rose, chuckling. "Hi, there, Joe," he said to the night watchman. "How are things going? Seen anything suspicious tonight?"

"No, sir," Joe answered. "Just Doug, as usual, burning the midnight oil in there."

"Doug's in there now?" Sheldon asked. "At midnight?"

"He's been spending a lot of nights at the office lately," Joe said. "You're going to have to give him a raise."

Home at last, Sheldon poured himself a shot of Jack Daniel's. He tossed it back, poured another, sipped it swiftly, then tiptoed up the stairs to the second floor of the mansion. As he walked down the hall he heard the rasping snore from his wife's uncle's room, a sound he'd always despised.

"Sweet dreams, Uncle," he murmured. "May you sleep forever, you old french-fried coot."

"I beg your pardon, sir?"

Sheldon spun around to face James, who was standing behind him, wearing a plaid bathrobe. The butler was a tall man, a strong dour Scot, slow to smile, devoted to his master.

"Nothing," Sheldon muttered. "Good night, James."

"Good night, sir," James answered calmly. "May you sleep...well."

 # Second Round

1 Approach Shots

June awoke first and had the pleasure of gazing at the sleeping face of her own private detective. His hair was tousled, and his jaw was scratchy with stubble, but his face was serene, with the half smile of a child in a trouble-free dream. Too good to resist. June snuggled in close to him and kissed his nose.

His eyes fluttered open and his friendly smile grew into a friendlier grin. "What time is it?" he asked.

"We have time."

After June and Win had showered and dressed, they found breakfast waiting for them in a basket outside their door. They brought the basket back into the room and opened it up on the room's little round table. Two of everything: milk, orange juice, croissants, bowls with strawberries, and small boxes of cold cereal. There was also a note from the manager that read, "Dear Guests, you'll find a coffeemaker in the bathroom. We've measured and filled it for you. All you need do is plug it in."

"I'll make the coffee," June offered. "You set the table. After breakfast I have an announcement to make."

They ate slowly, almost as if their mouths were too busy smiling to chew. When the last bite of cereal was gone and the coffee was drunk, Win wadded up his napkin, tossed it across the room into the wastebasket, and said, "Two points. Now. What's your announcement? Wait. First let me tell you something. I'm pretty sure I know where Skylark is."

June clapped her hands. "You mean you've solved the case?"

"Well, no. I don't know where the *design* is. But I do know where he's planning to build that golf course." He gave her a proud smile.

Great, June thought. There goes my announcement. "Oh really? Where?"

"In Monterey County," Win said triumphantly. "It came to me in the middle of the night. Yesterday when I was talking to Chip, I asked him if Sheldon would face any problems building a golf course on coastal wetlands, and he told me Sheldon plays golf with the powers that be, the county board of supervisors, planning commission, guys like that. Well, you know that means it has to be in this county, right?"

Win was obviously so pleased with himself that June didn't have the heart to steal his thunder. She kissed him sweetly on the cheek and said, "Come on, genius. If we hurry we'll have time for a run on the beach before we have to meet the boss."

"Wait," he said. "Your turn. What's your announcement?"

"I'll tell you later."

The beach was beautiful, with high walls of creamy white surf crashing into shore, sounding like thunderclaps as the water's force broke against the sand. Piles of kelp lay strewn about like stringy clumps of spinach, making the couple's run an obstacle course. They also had to dodge the dozens of happy dogs who had taken their owners out for morning walks and were now loudly chasing indignantly squawking shore birds.

They passed a lovely senior woman in elegant sweats, who was walking the other way, holding the leashes of five dogs of various sizes, all of whom trotted along politely beside her. The woman smiled brightly at June and said, "Good morning."

As they ran on, June said, "My gosh! Win, she said hello to me!"

"So?"

"Do you realize who that was?"

"I've never seen her before in my life," Win said.

They slowed their run to a walk. "You have too," June told him. "She used to be my hero when I was a little girl. I had such a crush on her! She was my secret love."

Win gave her a cocked eyebrow and said, "Whatever."

"Exactly!" June laughed. "Whatever will be, will be."

High atop the sea cliff above them, the famous Pebble Beach Links seemed placid. The yellow flags of the ninth and tenth holes gaily waved to incoming golfers. "Someday," Win told her, "I'm going to be up there. You just wait."

June took her lover's hand. "Okay," she said. "Here's my announcement."

"Yes?"

"I've decided to take up golf," she told him.

Harry Winslow stopped walking, tightening his grip on June's hand. "Do you mean that?" she heard him ask.

She shyly looked into his eyes and found them merry and wide. She nodded.

He folded her in his arms and said, "Darling, I've been waiting a year to hear you say that!"

She laughed against his chest. "Well, it's a big step," she said.

"What made you decide?"

"Last night," she answered. "Our charming host. He seems to have absolutely no respect for his wife, and a lot of it has to do with the fact that she doesn't play golf. I don't want that to happen to us."

"But it wouldn't!" Win protested.

"I know," she agreed. "But it occurred to me that if Sheldon and Carol Moore are any kind of example of a mixed couple— one plays golf, the other doesn't—then they're an example to avoid. Besides...."

"Yes?"

"You obviously have so much fun out there on the golf course. I want to be a part of it. I want to be a part of all your life."

He kissed her tenderly, and she kissed him back.

As they strolled back in the direction of the pavilion, she said, "Do you think our relationship can take it? I'm very competitive, you know."

They reached the pavilion just as Sheldon was pulling up in his red Porsche. He had the top down, and he was dressed like a man in charge, in a tweed golf cap, aviator sunglasses, a loud pink sport shirt open at the neck, and a red V-neck sweater adorned with the dragon logo of St. Andrews.

"Good morning!" he bellowed, as he coasted to a stop beside them. He reached over and flung open the passenger door. "Get in!"

June squeezed onto the minuscule shelf of a back seat, allowing Win to have the front seat. Sheldon eased the car out into traffic and drove south along a less-traveled road by the ocean. They passed homes with lavish lawns of pink flowering iceplant, gnarled cypress trees whipped by the wind, and giant boulders slapped by the sea into fanciful shapes.

"I wanted to have a talk with you two away from the office," Sheldon said. "So I thought we'd go for a walk. Fair enough?"

"Fine," Win said. "Where are we going?"

Sheldon slowed down for a double bend in the road, and then he pulled over and stopped. He took off his dark glasses and nodded at the vista before them. "What do you think of that?"

It was a great marshy meadow by the sea. To their left was a backdrop of humpbacked mountains. The meadow was waving with fall grasses and a few flowers, and flocks of birds played leapfrog in the reeds.

"Lovely," June breathed. "And what's that shining white area over there?"

Without answering, Sheldon pulled back onto the road. The meadow disappeared from view as they twisted and turned through a modest residential neighborhood. Then it appeared

again, even more beautiful close up. Sheldon drove up a hill and then down a driveway through an arch marked "Mission Ranch."

He parked beside a compound of white clapboard buildings that looked like turn-of-the-century farmhouses, complete with geraniums spilling from pots on the porches. Pricey cars parked here and there let them know this was no ordinary working ranch.

"Clint's place," Sheldon announced.

"Eastwood?" Win asked.

"That's right," Sheldon said. "He owns this hotel. Come on. I want to show you something. Watch your step, it can be slippery here."

They followed him down a grassy slope to a white picket fence, beside which grazed a placid herd of sheep. The sheep looked up to observe the human beings approach, then resumed their brunch. As Sheldon opened the gate he looked back and observed Win and June holding hands. "You two look pretty cheerful this morning. I hope that means you're making progress."

"Great progress," Win answered. "June has seen the light."

"Does it shed any light on our case?" Sheldon challenged.

June nodded. "Yes. As a matter of fact, I think it does."

 Golf by Design

"Watch your step," Sheldon told them as he led Win and June farther into the meadow. "It tends to get a little soggy." The earth beneath them was springy and soft. The morning sun was hot and the air was still, buzzing with cicadas that hopped from reed to reed. The meadow was very much alive.

Win felt the moisture soak through his running shoes and into his socks. "Are we supposed to be out here?" he asked. "I

thought you weren't supposed to walk on wetlands."

Sheldon answered him with an indulgent smile. "Don't worry about it. As long as you don't shoot any egrets you'll be okay."

Win decided to get Sheldon to come clean. "You own this land, don't you?" he said.

Sheldon laughed bitterly. "Own it? I wish."

"This is it," Win persisted. "Skylark, right? Right here."

"Nope," Sheldon replied. "Good guess, but no cigar. I'll admit I tried to get my hands on this property about five years ago. What a great golf course I could have built here. I even had a preliminary design drawn up, a beauty. Would have been the pride of the Peninsula. Damn. What a shame."

"What happened?" June asked.

"Fell through," Sheldon answered. "They stopped me."

"Who's they?"

"Martin Ramsey and his merry band of ecofinks," Sheldon spat.

"Ramsey," Win repeated. "That name keeps coming up. Who is this guy?"

"A nut," Sheldon said. "Total loony. He claims to be an environmentalist, but he just targets golf courses. *My* golf courses. Hates golf, and he hates me. He has a following of misfits and malcontents. They spend all their time putting the kibosh on my projects, all over the state of California. If it weren't for them, you'd be standing on a beautiful fairway right now, approaching the fourteenth hole. Instead, you got mud and bugs."

"Well, I suppose it's good that somebody stands up for the environment," June said.

"Hah!" Sheldon replied. "Ramsey doesn't care a bit about the environment. He talks like Rachel Carson and he looks like John Muir, but the truth is he's a lot more like Ted Kaczynski, except that Kaczynski's got brains. All Ramsey's got is a loud voice, not to mention a whole arsenal of guns. He claims to be protecting the environment, but the fact is, he just hates the game of golf. He'd

be quite happy if they paved over the whole Pebble Beach area and put up factory outlet stores and Burger Kings if it meant getting rid of the golf courses. Go figure. He's like a badger. Wherever I go, he's there first, making a big stink, making it twice as hard for me to build my courses." Sheldon puffed out his cheeks, took off his shades, and looked Win in the eye. "So now you know why I'm not letting anybody know where Skylark is going to be built. Not even you. Not till it's a done deal."

Win nodded. "Fair enough," he said.

"I gather this Ramsey fellow and your uncle are friends?" June asked.

"Hmmph. In the first place, that old coot is Carol's uncle, not mine. But yes, the Wise and Ramsey families have been buddies for generations. They were early settlers here on the Monterey Peninsula, back even before the first golf course. They fought that one and lost, and it's been that way ever since. I'll never understand why some people just don't like golf."

"What I don't understand," Win said, "is why you'd want to build a golf course in a wetland area. It's flat, it's got no trees, it's soggy...."

"That's why I'm a golf course architect and you're not," Sheldon replied. "A meadow like this is perfect. And so is the place I'm going to develop for the sultan. Flat? We'll give it rolling hills. You want trees? We'll plant 'em. Soggy? No problem. We'll drain it."

"Then what happens to the native wildlife?" June asked.

Sheldon shrugged. "They're welcome to stay, if they want. Look, it's really a very environmentally sound plan. We're going to cut a burn right through the meadow."

"What's a burn?" June asked.

"It's like a deep trench," Sheldon explained. "Great for drainage. They use them a lot on Scottish courses. It's a channel that takes care of water runoff. It's like a river, running all around the area, providing a home for all those water creatures. In fact it will

be our only water hazard, but it will show up all over. And get this: it will be a collectible hazard. Balls hit into it will float to shore. Don't worry about the wildlife, missy. We're going to put bird-houses in the trees, once we have trees. The only birds we don't want are the damn migrating geese, so we'll have a couple of bor-der collies trained to chase them away."

"What's wrong with geese?" Win asked.

"You ever try to play golf when you're up to your ankles in goose poop?"

They laughed. Sheldon went on, "You get the idea. Skylark is going to be my finest accomplishment, my masterpiece. We're going to have five tee areas, so players of all abilities can enjoy the course. Gumdrop mounds to keep the balls in play. Love grass in the rough to snare bad shots. And it's going to be known as the environmental course of the future. We're not going to use chem-icals or pesticides on the fairways, and if the grass goes brown in times of drought, so be it. No paved cart paths; people will be en-couraged to walk. If someone wants to use a cart, it'll be expen-sive, and they'll have to ride in the rough and observe the ninety degree rule. The bunkers will be grass, not sand. Players will be encouraged to wear soft spikes. Metal ones chew up a course."

"They do?" June responded. "I thought golfers were supposed to wear spikes to help aerate the course."

"That's an old wives' tale. Anyway, this is going to be a revolu-tionary course. Back to basics, the press will love that. It's going to be a strategic design, not at all penal. Meant for fun, not champi-onships. You know the term 'championship course'?"

"Of course," Win said. "All of your courses are championship courses, right?"

"Baloney," Sheldon sneered. "Sure, we call them champion-ship in the brochures, but that's just a lot of hype. 'Champion-ship' is the most overworked word in the business. It's there to make the golfer feel like a champ. Actually, the best golf courses aren't the hardest. The best courses are the most fun. And that's

what Skylark will be. Fun. Even for average golfers. Did you know that only ten percent of the golfers in this country score below a hundred?"

"That makes me feel pretty good," Win said.

"That's what it's all about," Sheldon said. "Making people feel good. I like to make people happy. Then they'll come back often. Players at Skylark will get a free drop from any rub of the green situation. Winter rules, all year round. And get this: low green fees. And no tee times taken. First come, first served. See? A golf course for the people."

"You really are a humanitarian, Sheldon Moore," June said. Win detected a slightly mocking tone in her voice, but only because he knew her so well.

Sheldon beamed. "People waiting to tee off will have a nice, cozy, really elegant clubhouse, with good food and drink, and a practice putting area and a driving range for the restless."

"Sounds perfect," June continued. "Ideal. At least for anyone who wouldn't rather it remained a wetland meadow."

The smile slid off of Sheldon's face and he looked at her sternly. "Listen, Junebug," he said. "Right now that place is private property, off limits to everyone. By the time I get through, hundreds of people a day will be enjoying it. People will thank me every hour. This is an act of generosity on my part."

June smiled pleasantly. "Of course, Sheldon. No offense intended. I hope to play your course myself when it's built, if it ever gets built."

"Don't you worry about that," Sheldon snapped. "Nothing can stop me now."

"I hope you're right," Win said, gazing over Sheldon's shoulder.

"Of course I'm right. Who's going to stop me?"

"Knowing you, I'd say no one," Win admitted. "But I'm a bit concerned about the approaching army."

Sheldon spun around and followed Win's gaze. A gathering

in combat fatigues was marching directly toward them, led by a tall, white-haired, hatchet-faced grouch.

"Oh brother," Sheldon muttered. "Speak of the devil. I think that man tried to murder me last night."

Colonel Bogey's March

There were eight of them. Four men and four women. They marched forward, carrying signs that read:

<div align="center">

SAVE CARMEL!

GOLFERS GO HOME

NO MOORE POLLUTION!

</div>

"Damned idiots," Sheldon muttered as they approached.

"They may be idiots," Win observed, "but they're wearing sensible shoes." It was true: the Ramsey gang wore rubber waders, whereas Sheldon, Win, and June were soaking up their socks.

The miniature army halted in front of them. The leader stepped forward until he was only a couple of feet from Sheldon, who stood his ground, smiling back aggressively.

"Good morning, Martin," Sheldon said. "Fancy meeting you here."

"I know what you're up to, Sheldon Moore," the tall man sneered. "Well, you can't build a golf course on this meadow, we've seen to that. So you can tell your hired guns, or investors, or contractors, or whoever they are, to get the hell off of this property." He reached into the pocket of his combat blouse and pulled out a cigarette, which he lit with a disposable lighter. He exhaled smoke into Sheldon's face.

"Don't blow that crap at me," Sheldon complained. "That's not polite. And this isn't your property, Martin, so just relax."

"This is my mother's property, Sheldon Moore."

"What the hell are you talking about?"

"Mother Nature's property, and don't you forget it."

Sheldon chuckled. "Well, you tell your mother to stop being such an old lady. And you can stop being such an old lady, too. Martin, I'd like you to meet my associates, Harry Winslow and June Jacobs."

"Call me Win," Win said, holding out his hand.

Martin Ramsey ignored the offer. "Sheldon Moore," he said, "what are these people doing here?" His gang murmured in agreement behind him. A short, plump woman moved forward and stood beside Ramsey.

"Why Martin," Sheldon answered with a grin, "I brought them here to meet you. Win, June, this is Martin Ramsey and his lovely wife, Millie."

Millie Ramsey gave June and Win a shy smile, but Martin continued to ignore them. Smoking vigorously, he kept his eyes on Sheldon Moore. "What made you think I'd be here?" he wanted to know.

"I had my secretary call you first thing this morning and let you know I'd be dropping by here with a couple of consultants. I knew you'd show up. You always take the bait, Martin. You're so predictable."

Martin Ramsey finally looked at Win and June. "Who are you two?" he demanded.

"We're private investigators," June answered.

"That's right," Sheldon said. "I brought them here to meet you, Martin. They're investigating paramilitary gangs for the Treasury Department." He turned to Win and said, "This is the one I was telling you about. The nut with all the guns."

"Hey!" Ramsey exploded. "I've got permits for every one of my guns, so lay off!" He ground his cigarette butt out with his rubber boot, adding a new element to the fragile wetland marsh.

"Martin, I think we should go now," his wife suggested.

"Quiet, Millie," he snapped. Turning back to Sheldon, he said, "We know you're planning a new golf course. We have ways of knowing."

"Brilliant, Martin. Very sharp," Sheldon laughed. "I'm planning a golf course! Of course I'm planning a golf course. That's what I do for a living, Sherlock."

"Well it had better not be on the central coast," Martin growled. "I'll fight you tooth and nail. I'll ruin you, Sheldon Moore."

"You're making a fool of yourself, my friend," Sheldon replied calmly. "Of course that's easy to do, in your case."

Win had to admit Sheldon was winning this round. Even some members of the Ramsey troop were grinning.

Martin exploded in rage, took a step forward, pushed forth his arms and shoved Sheldon backwards. Sheldon lost his balance and fell onto his behind. Stunned, he sat on the soggy ground, looking up at the laughing radicals in combat clothing.

Sheldon got to his feet calmly, then reached into his pants pocket and took out a cellular phone. He unfolded it and hit one button once. "Carmel Police," he explained to Win and June. "I have them on fast-dial. Hello? Carmel Police? This is Sheldon R Moore calling, and I've just been physically assaulted. I need help right away."

Millie Ramsey tugged on her husband's sleeve, and he backed away. "Okay," he snarled. "You win this round, Sheldon Moore. Company—about face!" The strange troop left as they had come, marching with their posters held high.

Sheldon, still on the phone, canceled the emergency. "No, you don't have to come," he told the dispatcher. "I took care of it myself." He folded up the phone and put it in his pocket, then smiled at his team of investigators.

"How are you?" June asked.

"No broken bones," he said. "But I'd like to stand for a while with my back to an open fire. Is anybody else hungry?"

4 Locating the Sweet Spot

Sheldon zoomed his Porsche up the Mission Ranch driveway, swung to the left, took a hard right and abruptly stopped. "There it is, folks, the reason I wanted to make a golf course on that meadow." Before them stood the Mission San Carlos Borromeo, authentically restored to its eighteenth-century splendor, its caramel-colored walls and bell towers recalling the sanctuary of the past. "The final resting place of Padre Junípero Serra. This was the second mission he built, and his favorite. He was a wonderful man, that guy. A real hero."

"You don't strike me as a particularly religious man, Sheldon," June said. "No offense, but I'm surprised that you think so highly of anybody who wasn't a golfer."

"Junípero Serra and I are a lot alike," Sheldon replied. "He went up and down the coast of California building beautiful missions. I travel all around the world building beautiful golf courses. In a way, we both have the same vision for a better world: landscaping. That's why I wish I could have put my masterpiece right here. Right next to his."

Sheldon next took them to the Rio Grill at the Crossroads Shopping Center for lunch. Waiting for their table, they sat in front of a pleasant fireplace, slipped off their shoes, and dried their stockinged feet in the warmth of the fire. Sheldon stood over them, his back to the blaze. He ordered sherry for all three and when it came he toasted their assignment.

"Here's hoping you guys live up to your reputation," he challenged. "You've got less than forty-eight hours to deliver that design to me."

"I think you should tell us more about the Ramseys," June said. "I think they're an important part of this."

"Why?" Sheldon shot back. "Why should those nuts care

about a golf course that's going to be built halfway around the world?"

"Because," Win answered, "we know and you know that the golf course is going to be built right here in Monterey County. Come clean with us, Sheldon. If you don't, we can't work for you."

"Who told you that?" Sheldon demanded, his meaty face bright red.

"Who knows about it?"

"About what? Nothing. I mean nobody!" Sheldon's glare left Win's face and roamed the room. "Our table's ready," he announced. "Let's have lunch."

Once again Sheldon took charge of the menus and ordered for the whole table: BLTs all around. "And another sherry for each of us," he told the waitress. "And bring that right away."

When the drinks came, he said. "Okay. Let's just suppose, for the sake of argument, that I had a wealthy client from some foreign land who wanted to get involved in California real estate. Let's say he wanted to have a partner in the golf business. He comes to me and offers me five million dollars to design him a golf course and another ten million to acquire the land to be owned in equal partnership, and still another twenty million to build the course. Not to mention half the profits when we get the golf course up and running. I'm a businessman. What am I going to do? What would you do?"

"Sounds like a pretty sweet deal," Win admitted.

"You're damn right," Sheldon responded. "*Damn* right. And then suppose the whole thing gets wrecked just because some bunch of loud-mouth, radical, phony environmentalists get wind of it."

June said, "You mean the Ramseys."

Sheldon nodded. "They've shot down every project I've tried to start around here. They kept me from building a course on the

dunes that would have rivaled the best they have in Scotland or Ireland. Same thing happened in Carmel Valley, this great piece of ranchland I could have had for a song. I tell you, those people are vicious. And their leader is a bulldog."

"How do they do it?" Win asked.

"Shouting, chanting, protesting. Signs, petitions, town meetings. They recruit every blue-haired widow, every Berkeley dropout, every Sierra Club reject they can find. Referendums. Lies. Bombs. You name it."

"Bombs!" June gasped.

"Well, not yet, but I wouldn't be surprised. They're heavily armed."

"You said Martin tried to kill you last night?" Win reminded him. "What was that all about?"

"Some nut tried to run me off the road about midnight. At first I thought it was Doug, but he had an alibi."

"Why Doug?" June asked.

"The bastard hates me," Sheldon said. "Pure and simple. But it wasn't Doug. So maybe it was Martin. He's that crazy, and he hates me, too. Anyway, you can see why I don't want my design to fall into the wrong hands. Which reminds me," he added, looking at Win. "Are you licensed to carry a gun?"

"Yes," June answered. "We both are. Why?"

"As this thing develops, I may need a bodyguard or two," Sheldon replied. He drained his sherry and put the glass down forcefully.

"Sorry, Mr. Moore," Win said. "We don't do that kind of work."

"Nonsense," Sheldon replied. "You work for me now. You do what I say. Ah, here's lunch."

The waitress set their sandwiches before them and left the table.

Sheldon folded up his napkin and put it back on the table. He stood up and said, "You people have a nice lunch. I'm not

hungry. You can add the tab to my bill. Work hard, you two. The clock's ticking."

"One more question, before you go," June said.

"Yes?"

"Just for the sake of argument, if you were to build a golf course in Monterey County for this foreign customer, this sultan, exactly where would it be located?" she asked.

"That's none of your damned business," Sheldon hissed. With that he turned and left, a weave in his walk.

Links to the Past

"I hope your socks are dry," June said, "because we've got a long walk back to the motel. Good thing we're dressed for exercise."

"I think we ought to go by way of the Monterey County Courthouse," Win suggested. "We need to do a little research."

"That's in Salinas, Win. How much exercise are you up for?"

Win grinned. "Okay. Back to the motel first. Then we do our research."

June grinned back. "What are we looking for?"

"I'm interested in the history of that meadow we just looked at. Sheldon says that's not the location of Skylark, but I'm not sure we can trust him on that."

"We can't trust Sheldon Moore on anything," June agreed, "but that's not where the golf course will be built."

"Oh?" Win challenged. "Do you happen to know more than you're letting on?"

"Skylark will be built right on Pelican Point," June said. "The Wise property. At least that's Sheldon Moore's plan."

"How do you figure that?"

"Well, think about it. Sheldon seems to have the real estate

problem taken care of, but nobody's been aware of him buying any property. At least nobody's made any noise about it as far as we know, and surely that weirdo Ramsey would have made an issue of it, if he knew—which he would if Sheldon had been acquiring any new property in this county. Chip seems to think the location's somewhere nearby. I think so, too. I think Jonathan Wise's family estate is going to have a burn cut through it within a year, and I think that lovely mansion of his is going to be serving cocktails to golfers."

Win reached across the table and took June's hand. "And I think you're one smart investigator," he told her.

"I think so, too," June laughed, "but to be honest with you I have to admit it's mostly dumb luck. This never would have occurred to me if I hadn't seen the design for Putt's new golf game."

"Now you've lost me."

"Well," she explained, "all of Andy's computer golf games are modeled on Sheldon R Moore the Third designs. I've seen his newest one, the one he's working on right now."

"And?"

"It's a dead ringer for the map of Pelican Point hanging in Sheldon's library."

"And how would Putt have been able to pull that off? You think he's the one who took the design?"

"Yes I do," June answered. "But I don't think he kept it. He had it long enough to scan it in sections so he could work on it in his computer, but then he passed it along."

"So it's still at large."

"Yup."

"There's only one hole in your theory," Win said. "The land doesn't belong to Sheldon. It belongs to Uncle Jonathan, and he'd never go for the idea."

"I know," June agreed. "There's only one way Sheldon could pull this thing off."

"How's that?"

"Over Uncle Jonathan's dead body."

An hour later, freshly showered and changed, Win and June left Svendsgaard's and drove the Tracer out of hilly Carmel and into still hillier Monterey. On Aguajito Street, above the Old Del Monte Golf Course, they found the stately white Monterey County office building. "It's not the main county courthouse, but it probably has some information we can use," Win said.

Armed with their AAA map of the area, they entered the building and scanned the directory of offices. "That one," Win said. "Planning Commission and Buildings Inspection. B-3. Let's go."

They clumped downstairs to the basement level, where, across the corridor from the county jail, they found the office they were looking for.

"Howdy," Win said to the young man on duty.

"May I help you?"

"Maybe you can," Win answered. "My wife and I are tourists. We were taking a drive and we saw a piece of property that looked awfully attractive. We wonder if you can give us any information about it, like whether it's ever been for sale, the size of the lot, who owns it, things like that."

"Do you have the A.P.N.?" the clerk asked.

"The what?" June responded.

"The Assessor's Parcel Number. We go by the numbers here."

Win unfolded the area map and circled Pelican Point with his pen. "This is the area we're curious about."

"Oh that. Pelican Point," the clerk said. "You and everyone else."

"Oh?" June and Win said together.

"Well, not really," the clerk admitted. "But there has been some interest lately. You see, it's been held by one family for over a hundred years, and now the sole owner's heirs have been making some inquiries. The owner's got to be about a hundred years

old. So it may be subdivided eventually, in which case you might be able to buy a lot there some day. But not now."

"Who are the heirs?"

"I've only met one," the clerk answered. "A Mr. Moore. His wife's the only living relative of the old man who owns the place."

"And Mr. Moore wants to subdivide it?"

"I really don't know. All I know is he came in and ordered copies of all the records, including the map of the plot."

"Could we see that map?" June asked.

While the clerk was away from the counter, she whispered to Win, "What's this 'My wife and I are tourists' line?"

Win smiled sheepishly.

"You wish," she prodded, thinking to herself, *I wish*. Aloud she said, "I'm no tourist."

The clerk returned and unrolled a large plot map. There it was, the same shape she'd seen twice before, as well as on the AAA map.

"It's an interesting parcel," the clerk said. "It's the only marshland in that area, surrounded on one side by forest and on the other side by the sea. Also it's huge, about two hundred acres. That's ten times the maximum size for a private estate in Pebble Beach."

"How do they get away with it?" Win asked.

"Grandfather deal," the clerk explained. "They didn't have that restriction when the original Wise bought the land. Of course, that's what Mr. Moore wanted to know, too."

"Oh?"

"He asked me if the grandfather entitlement would stand, or whether the land would have to be divided up and sold off if Mr. Wise should pass on."

"What did you tell him?"

"I told him I'm not a lawyer."

"And what did he say?" Win asked.

The clerk scratched his head and said, "He looked at me like I was worthless and dumb. Then he told me he knew plenty of

lawyers. He left this office without a word of thanks."

"Well, I guess we know all we need to know," Win said. "You've been very helpful."

"Yes," June added. "And one thing more?"

"Yes?"

"Thanks."

The Fringe Element

"What's our next stop?" June asked brightly as the pair of investigators skipped out of the county building hand in hand. "Are you thinking what I'm thinking?"

"Without a doubt," Win answered. "Let's go have a chat with the Ramseys. They may be from outer space, but if anybody knows more dirt on the famous Sheldon R Moore the Third, they're the ones."

"And they'll be ready to share any dirt they've got, I bet," added June. "Problem is, how are we going to find them?"

"I can solve that one," Win said. "It's an old trick I learned as a detective on the police force."

"Oh?"

"Phone book."

The Ramseys lived in a modest but pleasant neighborhood. The one-story houses were painted in pale pastels, each in harmony with its neighbors. The house they were looking for was the most attractive on its block, set off by a hillock of luxuriant ivy. A low, graceful brick wall edged the driveway, and a gay profusion of flowers spilled over the wall and out to the street.

"I don't get it," June said. "I expected them to live in a cabin in the forest, like the Unabomber. Either that, or in some man-

sion on a mountaintop, guarded by mastiffs. Aren't the Ramseys supposed to be an old, established family in these parts?"

"Sorry to disappoint you about the mastiffs," Win said. "You'll have to settle for that guy." He pointed at a large Persian cat who was sunning himself on the windowsill and warily eying their approach.

There was no bell, but there was a brass knocker in the shape of a cannon. Win banged it against the brass plate, and they heard footsteps inside.

The door opened. Millie Ramsey stood there, her plump face in a nervous smile. "He's not here," she told them. She wore a flowery house dress and had an apron tied about her waist.

"That's okay, Mrs. Ramsey," June assured her. "As a matter of fact, we were hoping we'd get a chance to speak to you alone. May we come in?"

Millie's smile pursed tighter, but it remained a smile as she stepped aside and let them into her home.

The living room was pleasantly furnished with old but comfortable chairs and tables and an overstuffed sofa, currently occupied by a tabby cat, which Millie gently shooed away. One wall was given over to a vast rack of guns, ranging in power from small .22s to a semi-automatic rifle. Win did a quick count and came up with eighteen weapons on display. Who knew what secrets this house kept in other rooms.

Win and June sat on the sofa and Millie took a chair facing them.

"Your husband has quite a gun collection," Win said. He meant it as a complimentary conversation starter, nothing more.

Millie Ramsey obviously took it as a lot more. "Are you going to make him give them up?" she asked. The cheerless smile hung onto her face like a habit, but her mouth was twitching with nerves. "Are you going to take his guns away?"

"No, Mrs. Ramsey," Win assured her. "That's not why we're here."

"I wish you would," Millie whispered urgently. "I wish you'd make him get rid of all these guns."

"Does he do a lot of hunting?" June asked.

"Martin? No, he doesn't hunt. He just does maneuvers with his friends."

"Maneuvers?" Win repeated.

"That's right, maneuvers!" came the gruff voice of Martin Ramsey from the doorway to the kitchen. He strode in like a drill sergeant and stood in the center of the living room, staring down at his unwelcome visitors. He was still wearing his battle fatigues, and a five-o'clock shadow was creeping across his craggy face. "We do maneuvers and we stay prepared. We defend our rights. What have you been telling these feds, Millie?"

"We're not feds, Mr. Ramsey," Win assured him. "We'd just like to ask you a few questions."

"Not feds? So you're free-lancers? Mercenaries? Guns for hire?" Martin snapped back. "Same difference. Listen, mister, I got a legal permit for every one of those guns, so go back to Washington and tell Janet Reno to lay off. I have a right to defend my rights."

"Mr. Ramsey, we don't have anything to do with the government," June said, smiling hard. "Honest. We're private investigators, and we're working for Sheldon Moore right now, and…."

"Worse!" Martin stormed. "That swine. God damned golfer! You ask me, it's golf clubs that should be registered, not firearms."

"Golf clubs don't kill people, dear," Millie said gently.

Her husband snorted. "Right. Only golfers kill people. I tell you, they should outlaw all golf clubs. Then only outlaws would carry them. I gotta go." He strode over to the display wall and selected a shotgun, which he took down and shouldered like a soldier. He marched to the door, then turned back to say, "Millie, you keep your mouth shut." He slammed the door on his way out.

"Poor Martin," Millie sighed. "He takes things so seriously. I wish you'd persuade him to get rid of the guns."

"What does he have against golf, Mrs. Ramsey?" Win asked. "I'm just curious."

"It goes way back," Millie explained. "His father was quite a golfer, and also quite a gambler. Oliver Ramsey. Have you heard of him?"

"No, 'fraid not."

"Well, he used to have one of the big estates out in Pebble Beach, but he lost it in a golf game. He lost his whole fortune, along with the home that had been in his family for three generations. That place is now a golf course, and we're living in...this."

"I think you have a lovely home," June offered.

"Thank you," Millie said with a sweet smile. "I do, too. But Martin doesn't see it that way. He goes out to Pebble Beach every day."

"To visit the golf course that used to be his family estate?"

"Oh no," Millie said. "They won't let him on the property. He goes and does maneuvers on the Wise land."

"Jonathan Wise's place? Where the Moores live?"

"That's right. The Wise family and the Ramsey family have always been the best of friends. For generations. The Ramseys are always welcome to walk on the Wise property. It's written down, you see. We have that right."

Win paused until he was sure she was finished and then prodded her with, "Is that one of the rights your husband wants to defend?"

A cloud gathered on Millie's face. "I don't talk about my husband's rights," she said. "Those are his concern, not mine."

"What does he have against Sheldon Moore, other than the fact that he's a golfer?"

"He doesn't discuss that with me," Millie said.

"And yet you go with him on his protest marches, you help organize petitions, you...."

Millie stood up and twisted her apron in her hands. "Those are my husband's affairs," she said. "I go along because I'm a good

wife, but I don't know anything about them. I don't want to know anything about them. I thought you were going to talk to Martin about giving up his guns."

"No, ma'am," Win said. "We're looking for a missing golf course design, and that's all."

Millie's eyes widened, and her mouth twitched twice. Then she shut her eyes and said, quite firmly, "I don't know anything about that golf course design. I don't know anything at all."

Out on the street, Win held the door of the Tracer open for June and said, "What do you think now?"

"I think Millie knows more than she's telling. I think she's afraid of her husband. I think her husband's a nut." She got into the passenger seat.

"I agree with you there," Win said. "Anyone who hates golf is a nut to begin with." He closed the door and walked around to the driver's side.

"I think she's heard of the missing golf course design, too," June added, when Win was behind the wheel. "And I think she knows the connection to the Wise property. But she's clammed up on us. Now what do we do?"

Win started the car. He knew what he had to do. Sherlock Holmes played a violin to help him solve a case; he claimed it cleared the brain and allowed the facts to fall in place. Win didn't know how to play the violin. He didn't need a violin.

"I'm going to go to the practice range at Pebble Beach. I want to hit a couple of buckets of balls."

"Fine," June said. "I'll take the Tracer. I think I should go have a talk with Carol Moore."

Overlapping Grip

The door of the mansion opened, and there he stood, close-cropped beard, white gloves and all. He bowed slightly, with a trace of a smile and a slight lift to his eyebrows. That's one tall, good-looking man, June thought. Like a distinguished British actor, full of manly, quiet charm, with plenty of manners and plenty of brains.

"Good afternoon, Miss Jacobs," he said. His voice had a slight Scottish rumble.

"How good of you to remember my name," June responded. "I'm afraid I've forgotten yours."

"Byrd," the man responded. "James Byrd. Shall I announce you to Mrs. Moore?"

"If you would be so kind," June said, trying to sound teddibly, teddibly British. Oh my, she said to herself. Listen to me flirting with the servants.

"Why June, how nice to see you!" Carol chimed as she came down the winding staircase, her right hand outstretched.

The two women shook hands warmly.

"I hope you don't mind my showing up unannounced," June said. "Very rude of me, but...."

"Don't be silly," Carol broke in. "I'm delighted. I very seldom get callers. My husband doesn't really put out the welcome mat, if you take my meaning, and this place is so secluded. Oh, I'm happy to see you! Come out on the terrace with me. I'll have James serve us some tea."

"Lovely."

June followed Carol into the sunken living room, which seemed even more cheerful by daylight than it had the evening before. To think she and Win had been in this very room only eighteen hours before—so much had happened in the interim.

"You have such a nice home, Carol," she commented.

"Yes, I suppose," Carol said. "At least it's a fine old house. I don't know, Sheldon and I have never been quite happy here. Of course that's our fault, I suppose, not the fault of the place. But we've never really felt that the place is ours. In fact it's not ours, really. And Sheldon's the kind of man who needs to feel he's the lord of the manor. Oh well…. Come on outside. It's a beautiful afternoon. We can enjoy the view."

The two women walked out onto the flagstone terrace.

"That certainly is a view," June exclaimed. Meadowlands stretched almost as far as the eye could see, with only a ribbon of ocean shining on the horizon. For a moment June let her imagination take over, and the vista before her turned green, with rolling hills and trees, and a burn winding about the land on its way to the sea. Then she blinked again and the flat meadow returned, a concert of brown grasses and reeds waving gently in the warm October sunlight.

James appeared with a silver tea service. He set the tray on a glass table and arranged the teapot, cups and saucers, plates and napkins and forks, milk and sugar and lemon, scones, butter, and jam.

"Thank you, James," Carol said.

"Madam," he responded. He bowed and went back into the house.

"Please sit down," Carol said to June, and the two women sat facing each other. On one side of the table was a lovely arrangement of cut flowers, and next to it rested a pair of high-power binoculars. Carol poured and said, "Lemon or sugar?"

"Sugar," June said. "What the heck."

"Me too," Carol replied, and they both chuckled. "Now then. June, what can I do for you? I expect you're here for a reason. Is my husband giving you a hard time? He hasn't made any improper suggestions, I hope?"

June was stunned to hear Carol Moore speak so openly, so

bluntly about her husband. Very well, this was no time to beat around the bush. "Carol," she said, "how much do you know about your husband's business?"

"Golf course architecture? Not a thing. I couldn't be less interested. I realize that's your field, and I'm sure it's fascinating, but I take what you could call an active disinterest in Sheldon's, um, affairs."

"Do you know why Win and I are here? Do you know why he hired us?"

"Consulting on some course, I suppose?"

"We're private investigators, Carol," June said. "Your husband brought us here to find a missing design for one of his courses."

Carol laughed out loud. "Sheldon's lost a design? That's priceless. It must be driving him crazy! He never loses anything. Have a scone." She shook her head, still laughing.

June smiled as she took a bite of her scone. "Do you know anything about Sheldon's current project? The one he calls Skylark?"

"Sheldon never discusses business with me," Carol replied. "Which suits me fine."

"It's supposedly going to be built in Malaysia," June told her. "For a sultan."

"Oh, that. Yes, that's the one that's going to make us fabulously wealthy," Carol said. "That's the reason Sheldon took that tour of the Pacific Rim last spring. He came back with a sun tan, a big contract, and a new personal assistant young enough to be his granddaughter and old enough to take him for a ride. Well, that's fine with me. They can both go spend a year in Malaysia for all I care."

"That golf course isn't going to be built in Malaysia, Carol. That course is going to be built closer to home."

"Oh?"

Movement in the meadow caught June's eye. "May I?" she asked as she picked up the binoculars.

"Of course. Are you a birdwatcher?"

"Depends on the bird," June said. She adjusted the lenses and there they were, like toy mechanical soldiers plodding forcefully through the distant mire. "Ramsey," she muttered.

"Oh, you see Martin Ramsey and his friends?" Carol asked. "They come here almost every day. Like a bunch of Boy Scouts."

"How does your husband feel about that?"

"Sheldon hates it, but there's nothing he can do about it. Uncle Jonathan insists on allowing the Ramseys and their friends to enjoy his property."

"Martin seems to be having a good time," June observed.

"Oh, he loves this place," Carol said.

"I wonder how he'll enjoy sharing it with a daily crowd of golfers."

June put down the binoculars and gazed across the vast distance of the glass tabletop, to where Carol's lips were twitching and her startled eyes were almost audibly filling with tears.

 Backspin

As June was getting into the Tracer she was startled by the roar of another car approaching down the long driveway. She lowered herself in the seat so that she could observe unnoticed.

The visiting car, a green Toyota minivan, pulled up in front of the mansion's six-car garage, and an attractive woman got out.

The woman walked quickly around to the back of the minivan, jingling her keys, and opened the glass hatch. She pulled out three boxes of different shapes and sizes, then closed the hatch. She then walked over to the doorway at the far end of the garage, fumbled with her keychain, and let herself in, closing the door behind her.

Odd, June thought.

What's Barbara Sutton doing here in the middle of the afternoon?

Why should Barbara enter through the garage instead of the front door?

And how does she rate her own key to the house?

 The Range of Possibility

Although Harry Winslow had never actually played a round of golf on the Pebble Beach Links, he had often used the practice range there, which is beautifully situated across from the Pebble Beach Polo Field. On a warm October afternoon, you can enjoy the scent of towering pines, gnarly oak trees provide an illusion of privacy, and a golfer can shut out the static and just focus on lofting ball after ball into the blue and green distance. It's a peaceful way to lose track of a little time, getting into the swing of life.

Not to mention the cost. At five bucks a bucket, the practice range is the most affordable amusement Pebble Beach has to offer.

As always, the place was popular that Tuesday afternoon, and Win had neighbors driving off the mats on either side of him. They didn't seem to be chatty neighbors, though, which was fine with Win; all he wanted to listen to that afternoon was the whoosh of his swing and the sound of the sweet spot smacking the ball goodbye.

"So, you having any luck?"

Win turned to face the man at the mat behind him on the line. He was a good-looking fellow, about fifty years old, with gray sprinkled through his dark hair, a dark tan, and a wide smile. Nice clothes, and he wore them well.

The man offered his hand and said, "Greg Perry."

Win shook Greg Perry's hand and said, "Harry Winslow," hoping the conversation would end as quickly as it had started. "Call me Win."

"So how's it going?" Greg asked. "Any luck?"

"Oh, I'm doing okay today," Win answered. "Slicing a little, but I'll work it out. I still have another bucket to go."

Greg chuckled. "I mean, have you found Moore's design for him yet?"

"What?"

Greg nodded. "Skylark. Have you found the plan, or is it still at large?"

"How do you know about that?" Win asked. "Who are you, a friend of Sheldon's?"

"Hardly," Greg snorted. "Far from it. I'm what you'd call a rival. I design golf courses."

"Oh, right," Win said. "Barbara Sutton mentioned you."

"Barbara's a great gal," Greg said. "Sheldon's lucky to have her. In fact he's got a great little staff. Far better than he deserves. Of course, that won't last long."

"What do you mean?"

"Sheldon R Moore the Third is finally getting out of the golf course architecture business. Thank goodness."

Whoa, Win thought. Is this wishful thinking? "How do you figure that?"

"You figure it out," Greg said. "His customer will show up the day after tomorrow. If Sheldon can't show him the design he's paid five million dollars for, the deal's off, and Sheldon has to refund the five mil, which he hasn't got any more, from what I hear."

"Where'd the money go?" Win asked.

"From what I hear, it's turned into a Porsche, a condo in Maui, and a four-bedroom beachfront home in Pacific Grove registered in the name of Sheldon's Tonga Toy."

"Sounds like he'd better find that design," Win said.

"That's why you're here, right?" Greg countered. "You and your partner? Go ahead and drive your bucket, by the way. Don't let me disturb you."

Win chuckled. This guy knew he had Win by the curious tail. "You seem to know a lot about Sheldon's affairs, Greg."

"It's a small community," Greg answered. "I keep tabs on the gossip, sure. I love watching that man squirm. I like to imagine the possibilities."

"Well, I'm not too fond of the man myself, having known him for only one day. But we'll do our best to find that design, save Sheldon's butt, and keep him in business." Win teed up, addressed the ball, and let one fly.

"Very nice." Greg said. "That's the ironic thing," he added, with a knowing grin. "If you do find that design, and the deal with the sultan goes through, then Sheldon is going to close the business anyway. He'll be a rich man, and won't have to have that business anymore."

"But could he possibly give it up?" Win asked. "He seems to love designing golf courses...."

"Hah!" Greg snorted. "Sheldon Moore hasn't designed a decent golf course in his entire life. You and I both know he lives off his father's reputation and Doug Banner's talent. He's dying to get out of that business and do what he's good at."

"Which is?"

"Sales. Shmoozing. Hosting. Selecting people's wine. Being a big shot. That's Sheldon all over: living high off the hog and having people kiss his...ooh, nice shot! Where was I?"

"You're telling me about Sheldon Moore's future career," Win reminded him.

"Isn't it obvious?" Greg said. "He'll be an equal partner with the sultan, and he'll be the manager-owner of the classiest golf course in California."

"Oh? I thought the sultan's golf course was supposed to be in Malaysia," Win lied.

"Yeah, right. Where did you read that? *Golf Digest* or *Ripley's Believe It or Not?*"

Win slugged two golf balls to heaven before he spoke again. "Greg, I'm not sure how much I can confide in you. The truth is, I want to learn everything you know about this case, but since you're a competitor of my client...."

"Oh come off it, Win," Greg said with a laugh. "It's common knowledge. Sheldon's going to build that sultan's golf course right here in Pebble Beach, right on the land where the Moores live."

"Everybody knows this?" *Shank!*

"Well, not everybody, of course. It's not public information, but everyone on Sheldon's staff knows it. And since I'm good friends with Doug...."

"Wait a minute," Win said. "Everyone on the staff told June and me they didn't know where the course was going to be built. And Sheldon told them all to tell us the truth, the whole truth. I heard him say that."

Greg smiled kindly. "Well, it's possible that what he told them in front of you is not what he told them before you and June arrived." He moved back to his own mat and hit a couple of balls, then said, "The point is, everyone who works for Sheldon knows what he's got up his sleeve. The only people who don't know are his family."

"His wife?" Win asked.

"She doesn't know. Lord, no. Nor does the old man, that uncle. He doesn't know, and it's a good thing. It would kill him."

"Oh?"

"He's got a weak heart. In fact, he should have died long ago. Sheldon can't really get his hands on that estate until the old man dies, but that should be soon enough to suit the sultan."

The two golfers went back to their mats and teed up. Their shots sailed out together, like old friends.

"That still leaves us with the problem of the missing design," Win mused. "Sheldon may be planning to close up shop, but I'm

sure he'd rather do it with a great new career than with a five-million-dollar debt."

"Or worse," Greg added. "I guess I wish you luck. Either way, Doug will be out of a job, which will be my good fortune."

"You seem to know Sheldon's staff pretty well," Win observed. "Who do you think took it?"

"You want to know the truth?" Greg answered. "I think it was Sheldon R Moore the Third."

"Sheldon stole his own design? Whatever for?"

"Possibly to keep it hidden from everyone else, so nobody else would be able to steal it."

"And why would anyone else want to steal it?"

"To embarrass Sheldon Moore. To scare him. To get his arms broken off, possibly. Or maybe to keep the deal from going through."

"So in fact it could have been anyone who doesn't like Sheldon Moore, anyone in the office."

"Possibly," Greg admitted. "But I'm betting on Sheldon. I'm betting he'll produce the design when the sultan shows up, and not before. Unless he shows it to one other person."

"Who's that?"

"Jonathan Wise," Greg answered. "As I said, that would probably give the old man another heart attack. It would possibly finish him off. Which Sheldon wouldn't mind a bit. I think the old man's life is in danger—imminent danger. It would help Sheldon out a lot to have him out of the way before the sultan gets here."

Win picked up what was left of his bucket of balls. "We're taking up space here," he told Greg. "There are people waiting for our mats. You want to go have a beer?"

"Actually, I have to run," Greg said. "I'm meeting Doug over at his office."

"Maybe I'll see you there," Win said. "My partner and I were planning to spend some time over there this afternoon." The two

men strolled together to turn in their buckets.

"I don't think Sheldon's got the design," Win said. "It doesn't make sense. If he knows where the design is, why did he bring June and me down here, at great expense, to find it?"

"You have a point," Greg admitted.

"He sure didn't bring me down here to play golf," Win added. Then, seeing the Tracer pull into the parking lot, he said, "There's my partner. Nice chatting with you, Greg. Thanks for your insight. There are more possibilities than I thought possible."

"Hey," Greg said with a grin. "Anything's possible."

 Gimme Gimme

That sweet man, the one Barbara liked to think of as her boyfriend, was waiting for her in the back seat of the Rolls Royce. She placed one of her packages on top of the automobile. Then, tucking the other two packages under her arm, she opened the door, climbed in beside him, and planted a chaste kiss on his cheek. She placed the packages on the floor, then turned to give her boyfriend a wide-eyed, admiring smile.

As usual, Jonathan Wise was nattily dressed, with a paisley ascot tucked into the starched collar of his blue oxford-cloth shirt and a bachelor button tucked into the lapel of his smoking jacket. Even in the dim light of the closed garage, his eyes twinkled merrily.

"Hello, my darling," the old man cackled. "Good of you to come, as always."

"Hey," she said. "I love our Tuesday trysts, Uncle Jon. You're my favorite guy. How've you been?"

"Older than dirt," he answered, with a wicked wink. "That's

why I've got such a dirty mind. Did you bring me my contraband?"

"You don't really love me," Barbara teased. "To you I'm just a delivery person. A middleman. A drug dealer."

"Come on," he urged. "Open the box. Let's have some! You like it as much as I do, admit it."

She patted his knee. "You're an impatient boy today," she chided. "I think we should talk a little bit first. I have something important to discuss with you. After all...."

"Can't we talk while we're doing it?" he pleaded. "It's been a whole week. How long are you going to make me wait?"

Barbara chuckled. "Okay," she said. "But just one piece." She reached down and picked up the box of See's chocolates, which she delivered into his eager fingers.

Jonathan tore open the box and folded back the layer of paper to reveal the chocolate squares, arranged in sinful rows. He gave her a wicked grin and said, "Nobody knows we do this."

"That's right," Barbara said. "James thinks you're upstairs napping. Sheldon thinks I'm running errands for him. Jonathan...."

"The dark ones are the best," he said. "Here." He chose a chocolate for her and placed it in her mouth before she could speak. Barbara really didn't care for chocolate that much, but for his sake she rolled her eyes and softly squealed.

He responded with a sensual growl as he popped a chocolate into his mouth. Then another.

"No more for me," Barbara protested as he tried to feed her another candy.

"Then let's open up the other package," Jonathan said.

"That's for later, Uncle Jon. You know the rules."

He gave her a shy, embarrassed smile, properly chastened. What a dear man, Barbara thought. Like a little boy. *My* little boy. She slowly traced a fingernail down the front of his shirt, gently tapping his buttons along the way.

"I did bring another package, though," she told him. "It's

something I want to show you. And then you and I have to have a little talk."

"What about?" Jonathan asked, reaching for another chocolate.

Barbara took the chocolate box away from him and said, "You can't have another till we have our talk. And then, if you're good I'll let you have a teensy sip of brandy."

"Now you're talking!" He reached down for the other package at her feet, but she blocked him.

"No, dearie," she said. "First we talk."

"About what?" Jonathan asked again.

"Your property, Uncle Jon," she answered, laying a hand on his knee. "We need to talk about your property."

11 Bump and Run

Win and June met up with Greg Perry in the parking lot of Sheldon's office. Win introduced June to Greg, who said, "I wish you two a lot of luck in this case. It won't save Moore's career as a golf course designer, but it could save his life. Less messy that way, wouldn't you agree?"

"Win tells me you think Sheldon's getting out of the business of designing, one way or another," June said. "I suppose that's good news for you."

"I couldn't be happier," Greg admitted. He held the door open for her, and the three of them walked into the muraled reception room. "I love this room," he said. "Doug Banner's the most talented golf artist in the world. I wonder where Barbara is?"

Win said, "So you're here to court Doug away from Sheldon, is that it?"

Greg held his finger to his lips and whispered, "These walls have ears."

"You're damn right they do!" boomed Sheldon Moore's voice from the intercom. The portrait of Arnold Palmer swung back and Sheldon burst through the door into the outer office, a Snake Eyes putter in one hand. "What the hell are you doing here, Perry?" he demanded. "I have nothing to say to you."

"Glad to hear that, Sheldon," Greg answered. "I'm not here to see you. I came to have a chat with a real designer. Is he in?"

"My staff is too busy for social calls," Sheldon said.

"Hey, cool down," Greg said. "Really, Sheldon, you seem so nervous! You ought to take up golf." With that he turned his back and walked down the hall in the direction of Doug's office.

"Come in here, you two," Sheldon fumed, leading the way into his inner office.

June and Win did as they were requested, and when the door was closed they took their seats in the leather armchairs while Sheldon paced the floor in front of them, waving his putter as he spoke.

"So give me a report. Any progress?"

"We've found out quite a bit since we last saw you," Win answered.

"So where is it? Who took it, and where is it now?" Sheldon demanded.

"We don't know," June answered.

"Well, God damn it, what am I paying you for?" Sheldon exploded. "You people don't seem to understand this is a serious problem." He consulted his watch and added, "We're running out of time! It's already four-thirty; where have you been all afternoon? I hired you to perform, and so far you've done nothing but ask me irrelevant questions about my private affairs, eat meals at my expense, tie up my staff's time, and make friends with my enemies." His voice grew louder and louder as he continued. "You're as worthless as the rest of them. Bunch of incompetent, disloyal, candy-ass...."

"Sheldon?" June interrupted softly.

"What?"

"Does that little light on your desk mean your intercom's still on?"

Sheldon jerked his head, then raced toward his desk, stepped on a Titleist ball, lost his balance, and flung the putter across the room as he began to fall. Win jumped to his feet and caught Sheldon's shoulders just in time to keep his head from cracking on the side of his desk. The putter clattered against the armoire.

Sheldon recovered his poise and sat behind his desk. He switched off the intercom. He took a deep breath, then scowled at his investigators. "All I'm saying is.…"

It was Win's turn to interrupt. "Sheldon, I think you'd better cool down. We'll go do our job and check in with you later. We have a few more questions to ask of your staff." He and June rose to their feet.

"Fine," Sheldon spat back. "Collect some more lies."

When they reached the door, June turned back and asked, "By the way, Sheldon, where's Barbara today?"

"She's running errands. She does that on Tuesday afternoons. You got a problem with that?"

June and Win decided that each of them should revisit the same people they'd chatted with the day before. June found Andy Putnam's office unoccupied, as she had the last time, and so she sat down again at one of his computers, where jumbo golf balls bounced randomly about the dark screen. The Venetian blinds were shuttered down, and the room was close and dark and quiet, humming with electronic secrets.

Hoping to find another golf game, June moved Putt's mouse and the screen saver vanished. This time there was no game on the screen, but just a number of icons representing documents and applications. One of the icons was for Eudora, the e-mail program, so June decided to use the time by checking her e-mail. She double-clicked on the Eudora icon, and a rooster crowed.

"You have mail," the screen told her.

Instinctively, she hit the "Enter" key. Oops. This wasn't her mail, it was Putt's, and she had no business opening it. She certainly wouldn't read it. She'd close it immediately. Of course to do that, she'd have to look at the screen long enough to see—

"Got it! Way to go, Putt! You're a genius! —Greg"

She closed the message, wondering: Got what?

What's legal? What's polite? Well, June figured, I certainly would not open another document on purpose, but maybe it's okay to just look in the outbox and see what kind of mail Putt's been sending.

Click click.

And there it was: a record of all the email messages sent from this computer over the past days and weeks. And they were all to one person. *gregp@perrygolfdesign.com.* They all had the same title: *larklink.*

And June realized many things in the moment before all went dark. She realized that Greg Perry knew a lot more about this case than he was letting on. And so did Andy Putnam. And she realized that there was more than one way to steal a golf course design. Mainly, the big surprise was that she realized she was not above prying into other people's private business. In fact, that was what her business was all about. She'd struck pay dirt, and she wasn't going to quit now.

Click click.

June was used to having e-mail open instantaneously. This document did not. The little wheel went round and round and round and round, and then the screen went pitch black, as did all the other screens and lights in the room.

She swiveled around in her chair and faced the only source of light, where Andy Putnam's bulky body lurked in the doorway to the hall, his foot on the switch of a power strip.

"Get out of my office," he said quietly.

•

Knowing that Doug was tied up in a meeting with Greg, Win decided to start by having a chat with Chip. Finding the agronomist's door shut, he knocked softly. Hearing no response, he knocked again, louder this time.

He thought he heard a murmur from inside the closed office, and a shuffling of furniture. He knocked again.

A strained voice called out, "Just a minute," and then, after a pause of at least a minute, Chip's voice said, "Come in?"

Win opened the door and walked in, wearing what he hoped was a relaxed smile. The tension in the building this afternoon was thick enough to chew, but Win hoped a casual chat with the easygoing Chip might be both refreshing and productive. They could talk about dirt—either kind.

Chip sat behind his desk, a stiff smile plastered on his face. His hair was rumpled. His hands, balled into tight fists, vibrated like jumping beans on the desktop. "What can I do for you?" he asked. "Pardon me for not getting up. I'm sort of busy just now."

"Mind if I draw up a chair?" Win asked. "This won't take long."

"Uh, okay."

Win brought a chair over and sat facing Chip across the large, cluttered desk. Chip shifted uneasily in his seat. He seemed to be holding his breath.

"So," Win began, "have you thought of anything else since yesterday? Anything I might be interested in knowing?

"About what?"

The young man was obviously distracted. Win tried another approach. "What do you know about Greg Perry?"

"He's a good designer. His office is in San Jose, but he spends a lot of time down here, shmoozing the golf crowd. Why?"

"He seems to have a high regard for you and the rest of Sheldon's staff," Win told him.

Chip picked up a pencil and waggled it between his fingers, but offered no response.

"Have you ever thought of making a career move?" Win pressed. "Ever considered working for another firm?"

Chip answered with a glassy stare and widening eyes. His mouth opened and closed. Again.

"Chip, are you okay?" Win asked.

"Yeah. Yeah. Yeah. I, uh, I'm under a lot of pressure at the moment...."

Win smiled and rose to his feet. "Well, I'd better let you get back to your work."

June found Win out on the patio behind the building, juggling golf balls. He was a terrific juggler, and the exercise seemed to help him concentrate. Or so it looked from the fixed expression on his face. Or maybe he was just concentrating on the juggling. Anyway, he was keeping the balls in the air.

"So, partner," June said, "any progress?"

"This place is a zoo," Win responded. "The deeper we get into this case, the fewer straight answers we get." He added a bit of loft to every third toss, making the balls dance before her.

"It's a zoo all right," she agreed.

"You can say that again," said a voice behind her, and she turned to see Greg Perry emerging from the building. His toothpaste smile was gone, and he wore an expression of annoyance. "What do you say we three get out of here and have a beer over at the Tap Room?"

"That sounds great," Win said, "but we're not finished here yet." He plucked the three golf balls out of the air, one by one, and dropped them into his trouser pocket.

"What else is there to learn around here?" Greg pressed. "Bunch of cranks."

June said, "Something tells me you're not rooting for our success. Don't you want us to find that design?"

Greg returned her frank question with a cold stare and silence.

She tried another approach. "Your mood seems to have soured a bit, Greg. What happened in there?"

"What are you, some kind of therapist?" Greg snapped. "I don't have to explain my moods to you."

"We're just looking for information," Win said. "We were hired to find a big piece of paper, bigger than a breadbox, which appears to be lost in space."

"Cyberspace," June muttered.

"What was that?" Greg asked.

"Nothing."

Greg finally smiled, although it looked as if it took some effort. "Come on, you two. I'll buy you a drink. It's five o'clock: quitting time."

Win shook his head firmly. "We have more work to do here. Maybe we'll join you later, but I want to have a talk with Doug before he leaves for the day."

"Forget it," Greg told him. "Doug won't talk with you."

"Why do you say that?" June asked.

"Trust me," Greg replied. "Doug's not interested in talking to you. He told me so."

"That's a lie."

Greg, Win, and June all turned to face Doug Banner, who was approaching them across the patio with alarming speed. When he reached them he and Greg traded arrows of anger with their eyes. The silent confrontation lasted for a brief eon, and then Greg turned his back and left by the path around the side of the building.

"Mr. Winslow? Miss Jacobs? I *do* want to talk to you," Doug said. "The sooner the better."

"Fine," Win said. "Shall we go back into your office?"

"No, I've quit for the day," Doug said. "I usually go for a walk after work. Will you join me?"

"Of course," June answered. "Where to?"

"The Spanish Bay golf course. Meet me in the parking lot by

the beach there."

"Sounds great," Win said. "A nice place to end the day's work."

"My day's only getting started," Doug said.

 ## Irons in the Fire

Win and June drove past Pescadero Point and slowed down to appreciate the Ghost Tree, a Monterey cypress stripped of its foliage and bleached by the sun, wind, and sea. A little farther along, they passed the Lone Cypress, the famous symbol of the Pebble Beach Company, struggling to stay upright with the help of steel cables. "Poor thing," June remarked. "It reminds me of Uncle Jonathan." Then came Cypress Point, from which they could see all the way to the Point Sur Lighthouse, twenty miles to the south. The red sun was low in the sky, casting an amethyst sparkle onto the calm Pacific.

On past the gorgeous fairways of the Cypress Point Club and the oceanside holes of Spyglass Hill and the Monterey Peninsula Club, where lengthening shadows highlighted the contours of the fairways and greens, past the barking sea lions of Seal Rocks, and into the parking lot of Spanish Bay.

"All the more reason to take up golf," June mused.

"Hmm?" Win killed the engine of the Tracer and turned to face her.

"This is such a beautiful place, this Monterey Peninsula, and especially Pebble Beach. I don't expect we'll get another case here any time soon, so I need another reason to come back."

Win squeezed her hand and smiled tenderly. "Let's go," he said. "There's Doug."

"I come here almost every afternoon, on my way home," Doug told them as they walked along the shoreline, staying on the boardwalk as they were instructed to do by signs along the way. "I've got this thing about golf courses, and Spanish Bay is one of my favorites. But any golf course will do, really. I've always felt at home on the links. When my time comes to die, I hope the Grim Reaper takes me while I'm on a golf course. I keep a pair of spikes—soft ones, of course—in the trunk of my car. Whenever I'm stressed out, I just look for a golf course, change my shoes, and take a walk. And lately I've been stressed out a lot, believe me."

"I believe you," June said. "I don't know how you can stand working for that man. I mean Sheldon Moore, not the Grim Reaper. Is he always such a tyrant?"

Doug chuckled. "I've known him since we were kids, practically. He's always been high-strung. I swear he's going to die of a stroke someday, and between us, I kind of wish I could do the stroking."

They turned away from the coast and walked across a broad fairway. "Why is it you've never taken up golf, Doug?" Win asked. "Since you love golf courses so much."

"I tried it a couple of times," Doug said. "I just don't have what it takes to compete, even against myself. I go to golf courses to relax: to breathe the scent of new-mown grass, to hear the sound of sprinklers in the distance, to enjoy the green light and to feel the spring of sod under my feet. Every time I've tried to play the sport I get distracted by the atmosphere. Some people are good golfers. Not me. I'm a painter.

"Which reminds me. This golf course of Sheldon's? The one that's missing?"

"Yes?" June prompted.

"I stole it."

Win and June stopped walking. *You what?* they both asked at the same time.

Doug chuckled nervously and said, "Well, I guess you could say I borrowed it for a few days. All right. I stole it. It was about a month ago, when nobody was using it. I put another design in the tube so nobody would notice it was missing. I took it home, called in sick for a few days, and did an oil painting of Skylark. I had to do it on the sly, you see, because Sheldon refused to give me permission to do the painting. And I couldn't resist. It's in my garage at home. It's one of my best, a colored replica of the design, with every detail in place. The point is, I put the original design back when I was done with it. In a sense I'm guilty, because I did steal the design, but I'm not the one you're looking for now. That's one thing I wanted to tell you."

"There's more?" June asked, as the three started walking again.

"Uh, yes. I don't know who has the original design, but I do know that Greg Perry has another replica of it. On his computer at his office. He told me that today."

"Is that what you were so upset with him about?" Win asked.

"That's part of it. I like Greg, but he's got no ethics. None whatsoever. He offered me a job."

"What's wrong with that?" Win wanted to know. "He admires your work. He told me that himself."

"He's got this scheme going, and he wants me to be a part of it," Doug explained. "Now that he's got a copy of Skylark, and Sheldon doesn't, he plans to approach the sultan and sell him the design after Sheldon loses the deal. He figures Sheldon will be out of business, and he'll get to move in and take over."

"But how would that work?" Win asked. "We understand the design is for a piece of property Sheldon owns, or thinks he owns. How could Greg sell it?"

"Greg can find another piece of the coast somewhere, if the sultan pays for it," Doug explained. "It wouldn't have exactly the same shape, but he'd expect me to adapt the design as needed. It's actually a pretty sweet deal for me. Greg expects to get enough

capital to expand his staff. He'll move to Carmel, hire me, pay me a better salary than I get now from Sheldon, give me credit for all my work, and let me keep all the rights to my golf course paintings."

"And you're not tempted by that?" June asked.

"Of course I'm tempted," Doug answered. "But I'd never do it. It all hinges on Greg selling something that's not his to sell. That's Sheldon's design."

"But you did the design yourself," Win pointed out. "And if you join Greg's staff...."

"It's still Sheldon's design. I did it while he was paying my salary. Greg had no right to take the design, and he has no right to sell it, and I won't be a part of it."

"You're an honorable man, Doug Banner," June said.

Doug grinned shyly at the compliment. "And a thief," he added. "Anyway, I wanted you to know about all this, because I'm going to pull a couple of all-nighters and reconstruct the design, using my painting as a model. The design for Skylark is going to be on Sheldon Moore's desk on Thursday morning, along with my letter of resignation. He's going to think I stole it and then returned it, and that's okay with me. But I wanted you to know the real story."

"You're an honorable man," June repeated. "I mean it."

They sat at a table on the flagstone terrace of the golf shop, drinking beer.

"I love this place," Doug told them. "I was here on opening day, as a member of Sheldon's staff. Got to meet Robert Trent Jones, Jr., Tom Watson, and Sandy Tatum. All of them heroes of mine. Mr. Jones told me he admired my work. Actually he said he liked what *Sheldon* had done at the Tumblewood course in North Carolina, but since that was my design, I felt complimented."

"That must have riled you," Win said. "Hearing Sheldon get the credit for your work."

Doug folded his arms across his chest. "It's always been a problem for me, I admit that. But I count my blessings. I got to train under one of the best architects in the business, Sheldon Moore, Jr. When he died, the business naturally went to his son, and I got to stay on at a good salary, doing what I love most. It's an honor, really. There are only about six hundred of us in the whole country, less than a thousand all over the world. And I happen to know I'm one of the best. I don't need the credit, really. I have my painting for that."

"Speaking of which," June reminded him, "you'd better get home and get that painting. You've got a lot of work to do."

As they finished their beers, they watched the sun set over the Pacific Ocean. From out on the links, they heard the drone of a bagpipe wailing out "Scotland the Brave."

 The Unburied Lie

"What the hell is this?" Sheldon asked, when the bowl was put before him.

"Turtle soup, sir," James replied.

"Real or mock?"

"I really couldn't say, sir. I'll ask the cook if you wish."

"Why don't you decide for yourself, dear," Carol said from the other end of the long dining room table. "You're the expert on what's real and what's mock."

James returned to the kitchen, leaving the two of them alone.

"What's that supposed to mean?" Sheldon snapped.

Carol answered by tasting the soup and declaring, "I think tonight it's real for a change. Refreshing."

"Carol, I've had a hard day." Sheldon tasted the soup, shrugged, and said, "Whatever. Tastes okay."

"I'm sorry about your hard day, dear," Carol said. "Would you like to tell me about it?"

"Nope."

"Would you like to hear about my day?"

"Not especially," Sheldon said.

"Would you like to hear what I'm going to do tomorrow, Sheldon?"

Sheldon put down his spoon. "What are you getting at, Carol? What is this?"

"I'm going to go see my lawyer tomorrow, Sheldon. In Monterey." Carol blotted her lips with her napkin. Her hand was firm, untrembling. It felt delicious to be in control for a change, even if what she was controlling was an urge to throw silverware.

Sheldon stared back at her with a puzzled frown. "What the hell are you talking about? If you're thinking about divorce, you're out of your mind."

"Oh?"

"It's crazy," Sheldon sputtered. "Here I'm about to make millions of dollars, more money than you and your rich uncle have ever seen, and you want to leave now? Carol, this is a community property state. It would be foolish to walk out now. Think of the money you'd miss."

"Ah yes, the sultan's golf course," Carol mused.

"That's right, the sultan's golf course."

"In Malaysia."

"That's right."

Carol stood up, looked her husband in the eye, and said, "Mock turtle soup!"

"What?"

"You heard me. You're planning to build that golf course right here, aren't you? Right in our backyard! You want to sell my family home!"

Sheldon waved his arms. "Hey, hey," he whispered hoarsely. "Pipe down, will you? He'll hear you."

Carol zipped a finger across her lips, smiled primly, walked around the side of the table, and sat on the chair closest to her husband, facing him across a corner.

"Who?" she said.

"Who what?"

"Who will hear? James?"

"No, your uncle, damn it. What do you want to do, give him a heart attack?"

"Uncle Jonathan? Oh, he already knows," Carol told him calmly. "In fact he's going with me to my lawyer's tomorrow. We're going to take the Rolls Royce," she added, rolling her R's.

Sheldon shoved his bowl of soup away from him, placed his elbows on the dining table, and leaned forward to stare closely into Carol's face. "Listen," he said. "If you want a divorce, fine. But wait till after this deal goes through. Don't be an idiot, Carol. Think of the money involved."

"I don't think Uncle Jonathan would approve of your scheme, Sheldon," Carol said.

Sheldon put on his persuasive, conspiratorial smile, which reeked of mock turtle soup. "He'll never know. I don't plan to move any ground till after the old bastard buys the farm."

"But he already knows, dear," Carol reminded him. "I just told you that."

Sheldon hit the table with his fist. "How did he find out? How did *you* find out?"

"A friend of mine told me."

Sheldon snorted, "You don't have any friends."

"I do too," she retorted. "June Jacobs."

Sheldon's eyes grew large and his face went red. "That bitch. She's supposed to be working for me! I'll fire her. I'll sue her. I'll kill her, I'll...."

"Calm down, Sheldon," Carol said, laying a hand on his arm.

Sheldon took a deep breath. Another. Then he smiled sheepishly and said, "I've done this for you, Carol. You'll see. It will be

a beautiful golf course. My masterpiece, the best in the world. And Carol? *I've done it for you.* That's why I want to do it right here. For you. Sweetheart, I don't want a divorce."

"Who said anything about a divorce?" Carol said. "I never mentioned divorce."

"But you said you were going to your lawyer.…"

"That's right. And Uncle Jonathan's going with me. It shouldn't take us long. We're going to rewrite Uncle's will."

Sheldon's hands bunched into white-knuckled fists. "What the hell are you talking about?" he demanded.

"We're talking about a community property state," she reminded him. "I don't want to inherit this property when Uncle Jonathan dies. I've asked him to leave it to the Audubon Society."

James reappeared from the kitchen and said, "Shall I serve the salad, madam?"

"Yes, thank you, James," she answered. "I think we've had enough turtle soup. Please tell Beatrice it was divine."

14 Course of Action

"Hello. You have reached the residence of Colonel and Mrs. Martin Ramsey. This is also the national headquarters of the Coastal Intelligence Agency (CIA) and Keep Golfers at Bay (KGB). If you are calling to voice a complaint about our political activity or military maneuvers, I suggest you write a letter to the *Monterey Herald* instead. If you are calling for social reasons, or to supply vital information, or to voice support for our causes, you may leave a message after the beep. Stand firm."

Beep.

"Hello, Martin, this is Jonathan Wise. God damn it, you were right! That nephew-in-law of mine *is* planning to sell our land,

and he's planning to turn it into a golf course. And I have proof. That ungrateful, four-flushing slime! Well, don't you worry, Martin. Don't you worry a bit. He won't get away with it. He'll never get the chance. I'm going to kill him, my friend. I'll kill that weasel if it's the last thing I do!"

"Sir, may I make a suggestion?"

Uncle Jonathan slammed the receiver down and spun around to face his faithful servant, who had appeared silently in the bedroom.

Using his sand wedge to keep his balance, the old man squinted at the butler and said, "Yes? What is it, James?"

"I think we've had enough brandy for the evening, sir. Perhaps I should take that bottle now and put it in the liquor cabinet."

Jonathan meekly surrendered what was left of Barbara's second gift. "Thank you, James. You are a real spoilsport, you know that?"

"I'm only thinking of your heart, sir," the butler replied, adjusting his gloves.

"You take good care of me, don't you, James?"

"I hope so, sir." With that the butler left the room, taking the bottle with him.

Jonathan Wise chuckled and donned his smoking jacket. He felt the side pocket and grinned. He still had a full cheater, and the night was young.

Out of Bounds

In the afterglow of the sweet end of a trying day, Win stroked his partner's hair and said, "Did you really mean what you told me this morning?"

"Probably," June purred. "I can't remember that long ago. What did I say?"

"That you're going to take up golf."

She hugged him. "You bet," she said. "I hope you won't mind playing with a beginner."

"I can't wait. I enjoy everything I do with you."

"Well, as soon as we get this case wrapped up, you can help me buy some clubs. We'll use the money we get from Sheldon, and…."

Her voice drifted off, and Win thought she might have fallen asleep. Then she sat up in bed and stared down into his face, the glow from the bathroom light highlighting her tousled blond hair and the gleaming skin of her shoulders and breasts. He reached for her face but she backed away and said, "Win, I have a feeling we're not going to get paid for this case!"

"What do you mean?"

"Well, if Doug reproduces that design, Sheldon's not going to need the original after all. He'll probably cancel the investigation as soon as he sees what's happening."

"You may be right," Win said. "But we've still come out ahead. He's given us a couple of nights in this cozy room, not to mention a lot of good meals and scenery. He can't take those things away. These couple of days have meant a lot to me."

The smile returned to June's face. "Me too," she said. She lowered herself down onto one elbow and then settled back into his arms. "Still," she said, "I hope we can find that design before Doug gets finished with the new one. I'd like to feel we were able to accomplish what we came here for."

"Me too," Win agreed.

"You know, there's one person we didn't get to see again to-day. I wonder where she was?"

"You mean Selia?" Win guessed.

"That's right. The cute little courier, the one who handled that missing design more than anyone else was willing to admit

on the day it disappeared. I wonder where she was hiding herself today."

Win chuckled. "As a matter of fact, she was hiding under Chip Parr's desk."

"She was? How do you know that?"

"Just a hunch," Win said. "And the fact that I noticed a black bra hanging on the hook behind Chip's door as I left his office."

June laughed out loud. "What in the world do you suppose she was doing under Chip's desk?"

"Well, from the look on his face, I'd guess she was giving him a hard time."

It had been a long day. Sheldon was fed-up and frantic. In a matter of hours he'd have to make excuses to a posse of royal musclemen, or get his arms tied in a square knot, thanks to a crazy old coot who had no business being alive. In the meantime, his employees were screwing him to the wall, his competition was snooping around his office, his private eyes were double-crossing him, his household staff treated him like a day-old fish, he was being hounded by paramilitary nuts, and his wife was a giant pain in the ass.

At least he had one source of comfort left. He checked his watch. Nine-thirty.

He wasn't due at Selia's house until eleven o'clock, but if ever a man needed an extra hour of comfort, this was such a time. He grabbed a bottle of Tanqueray out of his library bar, slipped into the garage, and fired up the Porsche.

He drank as he drove, thinking out loud to the world: *You got a problem with that?*

By the time he arrived in Pacific Grove he was beginning to relax, to enjoy the play of the pavement under his tires. He was set for a good hour of exercise, the only amusement he liked better than golf. Sheldon R Moore was ready to tee off, stroke his way through the distance, take his time, and sink his putt.

He turned onto Mermaid Street and then suddenly hit the brakes. Pulling over to the side of the street, he doused the Porsche's headlights so that he could watch this unexpected development unobserved. A couple were embracing at Selia's door.

The woman wore a sweater and jeans and a flower behind her ear.

The tall, slender man wore a windbreaker and slacks. And boots. When he came out of the kiss and turned to face the well-lit street, Sheldon could see who he was.

Chip. Chip Parr.

Sheldon waited until Selia had gone back inside and Chip had walked around the corner at the end of the block. Then he rolled the Porsche back out onto the street and drove to the corner, where he could watch Chip get into his truck.

The truck was high off the ground. No wonder those headlights the night before had been so blinding in Sheldon's rearview mirror.

The red taillights came on and the truck eased away from the curb. Sheldon purred up behind the truck and, keeping his lights off, followed Chip through the streets of Pacific Grove until the truck went though the Pacific Grove Gate and into the Del Monte Forest.

Now it was Sheldon's turn to tailgate. He took a swig of gin, then turned on his brights and hit the horn, opened his window and shouted out into the night, "Run, you bastard!"

The truck took off, with Sheldon right behind it. Chip stayed on Seventeen Mile Drive, accelerating around curve after curve, as the road became Sloat and then Lopez.

Rounding the sharp curve just before Lopez turned into Sunridge Road, Sheldon went out of control. The Porsche spun like a top, back-to-front time after time. Sheldon felt the steering go wild, and all he could hold onto was the gin bottle between his thighs. He felt the car tip over on its right side and scrape the road as it spun, then right itself again. When the car finally came to

rest, it was on the shoulder, straddling a drainage ditch, facing back in the direction from which he'd come. The motor was still running.

Sheldon took another swig of Tanqueray, then flung the bottle out the window, into the forest.

Now what? Sheldon thought.

Selia. I'll deal with her tomorrow. She'll eat her green card for breakfast.

Chip. I'll deal with him now.

There was no catching up with a truck that was out of sight. But Sheldon had other ways to deal with that traitor. He slowly pulled the Porsche off the shoulder, back onto the road, and very slowly and carefully drove away from the scene of his spin-out.

He had a whole collection of exotic putters at the office. Any one of them would do the job. The Fat Lady Swings might be just the ticket.

16 Swinging Out of Control

Doug Banner took off his sweater and poured himself another cup of coffee. He had always enjoyed working late at night. There was something about the solitude and the quiet that gave him twice the energy, and a feeling of being in charge.

The design was coming along nicely. He'd been at the office for four hours, and already he could tell he'd have the job finished by the end of the next day, in plenty of time to save Sheldon's deal with the sultan. The route was all sketched out, the greens in place, the boundaries of the fairways indicated, the burn, the groves of trees, everything was down in black and white. The next phase was to ink in color samples throughout. Most of the inking would be done later. The main concern now was to get finished

with all the work that required referring to the oil painting, so that he could get that painting out of the building before dawn. He did not want Sheldon—or anyone else, for that matter—to know that he'd done the painting. More specifically, he did not want the world to know that he had stolen—well, *borrowed*—the original design to do it.

The painting now hung on the wall over his drawing board. It was a beauty. He stepped back and took another fond look. The fluorescent lights were not especially kind to the colors, but it was still a powerful and graceful canvas, with a nearly three-dimensional texture to it, and a soft vibrancy and even a playful humor. He especially liked the graceful winding burn that tied the pieces of the painting together like a russet ribbon, ending at the tip of the pelican's beak. It was clearly the best oil that Doug had ever done of any of his Sheldon Moore golf courses, and Doug had painted them all.

Sheldon of course had owned all of those paintings, had sold them in galleries, and had kept all but a fraction of the money he collected for them. Doug got only a small percentage. That had never particularly bothered him, because the pleasure of painting was what it was all about. He also had the pride of signing his own name to the paintings, which was more than he was allowed to do on the original designs.

An odd arrangement, to be sure. Medieval. Feudal.

Well, no more. The work in progress on Doug's drawing board was the last golf course Doug Banner would ever design for Sheldon R Moore III, and the painting on the wall was going to remain Doug's property. He had a three-step plan: 1, redraw the design; 2, keep the painting; and 3, quit the job.

And that list, especially the last item on it, was what was fueling Doug's all-nighter. More than the joy of working at night, more than the coffee, more than the pleasure of inks and knives and paper and pushpins, it was the almost tangible prospect of freedom that made Doug Banner whistle while he worked.

Hearing the sound of footsteps in the building, he shut his office door. He didn't feel the need to hide his work from the cleaning crew or from Joe, the night watchman, but he did not want to invite visitors. Joe could be insufferably talkative, and Doug had plenty of work to do without interruptions.

Even with the door shut, though, he was unable to ignore the noise of whoever was in the building. It wasn't a normal footfall he heard, but a stumbling and a bumping, as if a giant were stamping through and caroming off the walls.

And then came the crashes.

Doug opened his door and peered down the hall. The light was on in Chip Parr's office, and out of the office came the din of shattering glass, over and over. He cautiously walked down the hall and peered through Chip's door.

Sheldon Moore's back was turned. He was wielding a golf club at Chip's shelves, wildly smashing jar after jar of precious soil samples. Dirt and glass fragments were everywhere about him, on the floor, on the shelves, on the desk, on the walls....

"Sheldon?"

Sheldon swung around. His face was covered with dirt and dust, and he wore a mad grin. "What are you doing here?" he shouted.

Doug frantically stayed calm. "I'm working, Sheldon," he replied quietly. "And you?"

Sheldon lifted the putter high over his head and brought it down full force on the center of Chip's desk. Using it as a rake, he dragged a collection of jars to the edge of the desk and let them fall to the floor. He looked up at Doug and said, "I'm cleaning house."

"I just made a fresh pot of coffee, Sheldon," Doug tried. "Would you like a cup?"

"It was Chip, you know," Sheldon said, his head bobbing like a toy turtle's. "He's the one."

"The one what?" Doug asked. *Just have to keep him talking,*

Doug thought. *Maybe he'll come to his senses.*

"He tried to kill me last night, you know," Sheldon said. "Tried to murder me!"

"Chip?"

"Yes, Chip!"

"Why would he want to do that?" Doug asked.

Sheldon didn't answer. Instead he sank to one knee, lifted the putter over his head, and hammered the jars that had fallen onto the floor.

"Chip's going to be devastated," Doug observed. "He's been collecting those soil samples for years."

Sheldon looked up from his labor. He had tears in his eyes. "Good," he whimpered. Then he hung his head and bawled.

Doug approached him and laid a hand on his shoulder. "Come on," he said. "Come on back to my office, and I'll give you a cup of coffee. Here, let me have your club." He helped Sheldon to his feet and tried to take the putter away from him, but Sheldon held on tightly.

"Okay," Doug continued. "Let's go." He led the way, and Sheldon followed. They reached his office and Doug went to the coffee machine. Found a clean cup. Poured.

I just have to stay calm. Pour a nice cup of coffee, get him to sit down and drink it, maybe get him to go to the men's room and clean up, and while he's in there I'll dial 911, and I'll get Joe's attention, I'll....

"You!"

Doug turned and saw Sheldon in the doorway, his face a mask of mad fury.

"You're the one!" Sheldon shouted. "I knew it all along! *You're the one!*"

"What are you talking about, Sheldon?" Doug said.

Sheldon staggered down into the office, waving his putter, staring at the oil painting over the drawing board. "You're the thief!" he shouted. "The traitor! You'll die for this!"

"Wait a minute, Sheldon. Calm down. Here, have a chair. Sit. Have some coffee."

Sheldon took the cup that Doug handed him and walked over to the drawing table, breathing like an infernal machine. He looked at the work in progress, then up at the oil painting, then back down at the design. "You're not going to get away with this," he snarled.

"Sheldon, I am trying to save your ass," Doug said. "See? I'm redrawing the design so you'll have something to give the sultan."

"Don't give me that," Sheldon replied. "You're stealing my work. You think you can get away with that?" He held the coffee mug over the design. "Huh?"

"Sheldon...."

Sheldon poured coffee all over the new design, the whole steaming cup, destroying four hours of work and making a wet, brown mess of Doug's workspace. Then he slammed the cup down, raised the putter, and turned to face the oil painting.

Doug sprang forward and snatched the golf club out of Sheldon's hand just before he was able to swing it at the painting.

"Sheldon, sit down," he ordered. Doug held the club in a nonaggressive way, but his voice was firm. "Sit down, now."

But Sheldon R Moore III was not a man to do as he was told. Instead, he turned around, picked up an X-acto knife, and cut a two-foot diagonal gash across the best oil painting Doug Banner had ever made.

"Sheldon, stop!"

Then Sheldon turned around and said, "Give me back my putter."

"No way."

Sheldon took a step forward, holding the X-acto knife like a switchblade.

"Gimme!"

"No."

Sheldon lunged, and Doug ducked.

Sheldon lunged again, and again Doug ducked, but this time the knife pierced his shoulder. He dropped the putter, and Sheldon's foot landed on it.

"Now I've got you," Sheldon snarled. *"You* sit down."

Doug had better sense than that.

He ran.

 Deadly Trajectory

Doug drove past the Beach Club, slowed down, and turned off the road between a pair of high, thick hedgerows. He parked, killed his motor, leaned his forehead against the steering wheel, and took a deep breath.

He felt sheltered in this parking lot, which had been generously provided by the Pebble Beach Company for fishermen and divers, to give them access to Stillwater Cove. The lot was hidden from view, camouflaged by huge hedges to protect the golfing set from having to see the beat-up trucks of fishermen.

Now then, Doug thought. *My painting is ruined, my bridges are burned, I'm out of a job, I'm running from a madman, my shoulder is on fire, and…I'm happy. I'm free!*

Free is a relative term. Doug knew he had a whole new set of problems to solve, but for the moment he felt a surge of energy, a strange cocktail of adrenaline and euphoria. His body began to tremble and twitch, and he decided it was time to take a walk.

A walk on a golf course.

He got out of his car, into the chilly night. He had left his sweater in his office, and his left sleeve was soaked with blood, now sticky and cold. But the rest of his body was warm enough, especially if he kept up a good pace.

He began by walking out to the pier that extended into the

cove. The water, nearly transparent by day, was now inky and full of secrets. He ducked beneath the pier and carried on along the pristine beach for which the resort community had been named. The sand stretched from the fourth hole to one-third of the way along the sixth. Doug hiked the entire length of the beach, his head down against the sea wind, but his spirits high.

Maybe he'd take that job with Greg Perry after all. He certainly felt no more debt to Sheldon. And now it appeared that Sheldon was going to wreck every possibility that Skylark, Doug's masterpiece, would ever be built. With Greg, at least there was a chance. On the other hand....

When he reached the end of the beach, he clambered up the skittery loose rock bank onto the shaggy rough of the par-five sixth hole. Of all the holes on this famous golf course, the sixth was his favorite. Even though he wasn't a golfer himself, he knew enough to appreciate the beauty of this hole. It was a heroic test that required a super shot off the tee, and the ability to execute a slight fade, landing the ball a little right of center in order to avoid a massive bunker. From there, a bold second shot was required to clear the steep cliff and reach a beckoning plateau. Beyond that, the green lay hidden in a tiny hollow.

There, at its summit, the cliff was sixty feet above the sea. As high as a three-story building. Several greedy bunkers guarded the left side of the hill, the safe approach to the green, while the surging ocean cut off the right.

As if mesmerized by its treacherous beauty, Doug began climbing the hill. He realized his wound was bleeding again, the soggy wetness seeping farther and farther down his sleeve. He also realized that he was wearing the wrong shoes. He should have changed into his spikes; his sneakers were slipping on the fog-wet grass.

Finally he stood on the wind-whipped summit, fifty yards from the elusive green, the surf growling and smashing sixty feet below.

"Hey, Banner!"

The call came from the direction of the green. Doug turned and peered into the dark, where he could barely make out the figure of a man.

"Fore, sucker!" The voice was familiar, but Doug couldn't be sure, with the wind and the surf muddling the sound.

There was no time to think about it anyway. A glowing ball was speeding through the air, directly at him. A Nitelite golf ball, eerie and beautiful, whizzed by his head and sailed out over the ocean.

Then another. Then another. Like shooting stars they came, and Doug found himself ducking to stay alive. Whoever was driving off that green was a hell of a golfer. Doug knew he should retreat, but he was mesmerized by the fireworks. He ducked ball after ball, backing away from the line of fire, until he felt himself slipping, tripping on a root, stumbling, and lurching, his balance gone forever.

Time slowed down for Doug Banner as he fell sixty feet to the rocks below. He realized that he had had a happy life, in spite of Sheldon Moore. He regretted that he had not had a chance to say goodbye to Mary. He was happy that this last hour of his life had been spent on a golf course.

Skulled

The woods on either side of the driveway to the Wise mansion were black, but as Sheldon sped around the curves his headlights picked up countless signs of sinister life. The eyes of startled deer flashed back at him, and a raccoon lumbered off the shoulder of the road and scooted into the forest. Sheldon tried to keep his

weary eyes on the road before him, but his attention kept veering right and left, into the spooky forest, where he now saw his enemies darting among the trees. Soldiers.

Almost there.

He heard a scream. No he didn't. Yes he did.

It was only his own whimper as he hit the brakes and skidded through the last curve, into the parking area in front of the garage. He pressed the button attached to his sun visor, and the garage door rumbled open. He gunned his motor one last time and rolled into the garage, letting the door rumble down behind him.

He crawled out of his car and walked unsteadily to the door that led into the house, grateful that the day he'd just been through was finally over. His mind was still echoing with the shouts of his foes.

As he stumbled down the hallway he was surprised to see light coming from the front of the house. James usually left one light on for him in the front hall, but this was a full-lit living room he was approaching.

Muttering to himself about the waste of electricity and the incompetent butler who had left these lights burning, Sheldon stumbled down the steps into the sunken living room. There he found Jonathan Wise sprawled out on the couch, wearing a dressing gown and clutching a silver flask. The old man was snoring fitfully, his face in a scowl. *Disgusting.*

The room was cold and damp.

The French doors to the terrace were wide open, and a foggy breeze was drifting in off the meadows.

Sheldon went to close the doors, but then stepped out onto the terrace to investigate the suspicious activity he could barely make out in the distance.

Flashlights in the meadow? Who was that out there?

He picked up the binoculars from the glass table and peered into the dark. Yes. Definitely a crowd of people were marching through his land. Soldiers. Enemies. Martin Ramsey. Greg Perry.

Doug Banner. Chip Parr. They were all out there. Those private eyes were out there, too. He could hear them, calling to each other, ganging up, plotting, advancing.

I'm calling 911, he thought. He stepped back into the living room.

There he was, that old bastard. In that moment Sheldon realized he really had only one enemy. There was only one person standing between him and the success he deserved. And he wasn't even standing.

And he'll never stand again.

He was almost tempted to wake the old bastard up to say goodbye. But this was no time to take chances. *Fast and quick. Head down, follow through.*

Sheldon picked up a pillow from the other couch and bent over his wife's uncle. He pressed the pillow down on the old man's snoring face. The muffled snore went silent, and the face wagged back and forth in a struggle for breath, but Sheldon leaned into the pillow with all his weight and strength. The old man's body jerked and his legs kicked and his arms waved, the flask still clutched in his left hand.

God, this is taking forever, Sheldon thought.

And finally, the struggle stopped. The flask fell to the carpet and spilled a puddle of brandy.

Finally this day made sense. Sheldon R Moore III had accomplished something worthwhile after all. *It's my land now.*

Tomorrow will be better for both of us, he thought gently to the still body on the couch.

That was Sheldon's last thought. He did not have time to think about the fierce crack and the explosion of pain that erupted in his right temple and instantaneously engulfed the universe.

Final Round

1 The Dawn Patrol

Frank Stepko cut himself shaving when his pager went off.

Ouch. Well, at least the infernal device didn't wake him up this time. He was already up, getting ready to meet a real estate client for breakfast. Of course, this beep would probably mean canceling that appointment. He might not get breakfast until after lunch. And whatever the call was about, it was far more serious than a cut on the chin.

He took the call.

"Frank, we just got a call from the harbormaster at Stillwater Cove. There's a body lying at the base of the cliff below the golf course. Looks like he fell. He's on a ledge, just above the rocks."

"Alive?"

"Let's hope. Either way, we gotta get there fast. Tide's coming in."

"I'm on it."

Frank was the director of the Monterey Peninsula Search and Rescue Team, a volunteer organization linked with the Sheriff's Office. He went into action, dressing with one hand, punching phone buttons with the other.

Forty-five minutes later, he and his team of eight men met in the parking lot of the Sheriff's Office in Monterey. They all wore bright yellow slickers, with SHERIFF stenciled on the back and SEARCH AND RESCUE on the front. It was a gray, drizzly morning, and the men wiped moisture off their faces as they gulped coffee from Styrofoam cups and listened to the report and the game plan. Then they climbed into their four-wheel-drive vehicles and

took off together, led by an ambulance with lights flashing and siren blaring. They entered the forest through the Highway One Gate, sped down the curvy roads to the Pebble Beach Links, and parked by the second hole, where the golf course superintendent was waiting for them.

The superintendent led them on a shortcut through the golf course, following a cart path across the sixteenth fairway to the fourth and fifth holes, and to the sixth.

Frank's team hopped out of their vehicles, and Frank barked out the routine. "George, you're logistics. Gale, you're safety officer. Art, you got the radio. Terry and Bob, get busy with the winches. Charlie and Jake, I want you to get the Stokes stretcher ready; we're going to need major straps and cables. Clyde, you and I are on belay." Frank then turned to the medics who were readying the ambulance. "Which one of you guys is going to join us in a little rock climbing?"

"I'm your man," said a sandy-haired youth with a grin.

"You done this before?"

"Lots."

"Hey!" A civilian approached waving his arm. He was dressed in golfing clothes, but his hair was disheveled and he wore a wild, frantic expression on his face. "What can I do to help?"

"Sir," Frank said, "the most helpful thing you can do at this time is to stay the hell out of our way."

"But I know who that is down there!" the civilian said. "I saw him fall. I want to help!"

"You stick around," Frank said. "I want to talk to you. In the meantime, please stay out of our way." He turned to his team. "Okay, gentlemen? Let's do it. And be damn careful on the way down. I don't want to dislodge any rocks or pebbles that might fall on our victim."

When the equipment was prepared and the team in place, they started inch by inch down the slippery face of the eroded cliff. It seemed to take forever, but they made it without dislodg-

ing a single pebble, and when Frank's foot landed on the ledge beside the broken body of the victim, he felt the tide wash in over his ankle and knew they had arrived barely in time.

The man was unconscious, but alive. The medic confirmed that his vital signs were stable. With meticulous care, they wrapped him in the Stokes and lowered a protective mesh cage over the top, cinched the straps, checked the cables, and gave the signal to the winch men to start lifting.

The climb up went faster than the climb down. The whole team cheered when the stretcher was safely lifted over the edge of the cliff, and again as it was slid into the back of the ambulance.

"*Please.*"

Frank turned to face the civilian, whose face was a symphony of dismay.

"Yes sir? You say you saw this man fall?"

"May I go to the hospital with him?" the civilian begged.

"No sir, I don't think that's a good idea. I want you to come back with me to the Sheriff's Office and help me fill out the report. What is your name, sir?"

"I'm Greg Perry."

"Mr. Perry, you say you know this man we just rescued?"

"Yes, I do."

"Is he married? If so, I want you to get on my car phone and call his wife and tell her he's had an accident, and tell her that he's going to make it."

Perry broke into tears.

⚑ The Golf Widow

Wednesday morning June and Win decided to forgo the complimentary breakfast at the motel and go out for eggs and pancakes at the Tuck Box. Full and happy, they returned to their room and began putting on their running shoes when Win noticed the red light blinking on their bedside table. He picked up the receiver to take the message. The front desk put him through to voice mail.

"Mr. Winslow and Miss Jacobs, this is James calling from the Wise-Moore residence. I'm sorry to disturb you, but there's been some unpleasantness, and Mrs. Moore would be most grateful if you'd drop whatever you're doing and come to see her here as soon as possible. Thank you."

"Oh dear," June responded when Win relayed the message. "I wonder what that horrible husband of hers is up to now."

In front of the Wise garage were two squad cars that bore a motto on their sides: Keeping the Peace Since 1850. The pathway to the front door was blocked off by yellow crime-scene tape.

"Ye gods," June said, as they got out of the Tracer. "What do we do now?"

Before Win could answer, the door at the far end of the garage opened and James came out to meet them. He was dressed as formally as always, white gloves and all, but his face was creased in sorrow. It was the first time June had ever detected any emotion on his face.

"Thank you so much for coming," the butler said. "Please come this way."

They followed him into the garage. Nothing abnormal there, June observed: cars in place, matching golf bags leaning on the far wall, everything clean and neat, except—

"Good Lord! What happened to the Porsche?" The right side of Sheldon's red sports car looked as if it had done time in a

Cuisinart. "Is Sheldon all right?"

"No, madam," James answered. "Please come this way."

June took Win's hand as they followed James into the house. "Poor Carol!" she said.

"Yes, madam."

Carol met them in the front hallway and hugged them both. She was wearing black slacks and a black turtleneck sweater, and she had no makeup on. Her face was dry-eyed but distressed. She said, "Please come into the dining room. I'd like you to meet Detective Harris."

They followed her into the dining room, where they found a man in a sportcoat sitting at the head of the table. To his right was a young policewoman in uniform. They were going over a pile of notes, and she was making a list on a yellow pad.

The man stood up and held out his hand. "Hi," he said. "Ned Harris, Monterey County Sheriff's Department. This is Sergeant Amy Worth."

"Harry Winslow," Win said. "And June Jacobs. What's up?"

"Please fill us in," June said. "Has something happened?"

The look on Amy Worth's face was enough to say: You'd better sit down. Win held a chair out for June, and they took their places around the table: Detective Harris, Officer Worth, Win and June, and Carol. In the doorway, James said, "May I bring anyone a cup of coffee?"

Ned Harris nodded and said, "Milk, no sugar. Anyone else?"

No takers. James backed into the kitchen.

"Well," the inspector said, "I'll be blunt. I understand you're both experienced with police work? Good. And you've been working for Sheldon Moore as private investigators? Fine. Mrs. Moore has asked me to involve you in this investigation, and although I can't do that officially, I'll be grateful to hear whatever you might have to say."

James returned with a tray and placed a cup and saucer, a spoon and napkin, and a small pitcher of cream in front of the

detective, then returned once more to the kitchen.

"All right, here's the situation. We have two dead bodies in the living room of this house. One, Jonathan Wise, a man in his nineties, apparently died of a heart attack sometime around midnight. We're waiting for a medical examiner to get here, but it appears that he had drunk quite a bit of alcohol, and it also looks as if the heart attack was brought on by a lot of physical exertion."

June watched Carol's face carefully as the detective spoke. It was twitching and squinting, as if holding back either a flood of tears or a loud scream.

"And the other body?" Win asked.

"Sheldon R Moore," Ned Harris said.

"The Third," Carol added. Her face was calm now. "Don't forget 'the Third.'"

"Mr. Moore apparently died of a head wound," Harris continued. Carol nodded and pursed her lips.

"So you suspect foul play?" June asked.

Harris chuckled. "Well, Miss Jacobs, you know how conservative we have to be when we say things like that, but I think we can safely say this has gone beyond suspicion. Foul play is a certainty. Lead-pipe cinch."

"Lead pipe?" Win echoed.

"Well, not literally. Actually, a golf club."

"Which one?" Win asked.

"I beg your pardon?"

"A driver? A putter? Iron? Wood?"

"Well, I'm not a golfer," Detective Harris said, "and I'm not sure it matters, Mr. Winslow, but...."

"It was a sand wedge," Amy Worth said.

"That's what I thought," Win said. "Call me Win. May we have a look in the living room?"

Carol winced.

"Okay," Ned Harris said, standing up. "Of course I have to instruct you not to touch anything. But you two know all that.

Mrs. Moore, will you come with us, please?"

"Is that necessary?" June asked. Carol was clearly upset, and June thought she'd be better off upstairs, away from the unpleasantness.

"I think it would be good to have Mrs. Moore with us," Harris answered, "in case you two can think of any more questions we need answered."

"It's okay," Carol said. "I can handle this."

"Thank you, Mrs. Moore. You've been most cooperative. Shall we?"

The sunken living room was locked in time. The lamps were turned on, the doors to the terrace were wide open, one chair was overturned, the cushions on both sofas were disarranged, and an open silver flask lay on the carpet next to one of the sofas.

On that sofa lay the tiny, twisted body of Jonathan Wise, his face frozen in a grimace, his mouth and bloodshot eyes wide open. He wore a bathrobe and one slipper; the other slipper was on the sofa next to his foot.

Stretched across the coffee table between the two sofas was the mass that had once been Sheldon R Moore III. He lay on his back, staring nowhere. The murder weapon rested across his chest.

Win squatted down to take a careful look at the bodies and especially the faces of the two dead men. He examined the wound on Sheldon's right temple. Then, without touching, he looked at the sand wedge and the brandy flask.

Carol sat in a chair at the far end of the room and wept into her hands. June knelt and put a hand on her shoulder. "I'm so sorry, Carol," she said. "This is just awful for you."

Carol looked up and whimpered, "Poor Uncle Jonathan!"

Ned Harris said, "Well, Win, what do you think so far?"

"Have you checked out on the terrace and the backyard?" Win asked.

"Of course. Nothing."

"No sign of traffic? No tracks?"

"Not a thing. And it was a wet night last night. If anyone had entered from the lawn, or the meadow, or the woods, there would be tracks all over the living room. Had to be an inside job."

"Have you checked the weapon for prints?" Win asked.

"We haven't dusted yet. I've got a photographer on the way. I want to get pictures before we touch anything."

"I expect you'll find Mr. Wise's prints on the club," Win said. "And on the flask as well. They both belonged to him."

"Are you suggesting Mr. Wise was the assailant?" Harris asked.

"That seems to be the likeliest possibility. Of course, I'll be interested to learn what the fingerprints reveal. But my guess is that Mr. Wise came up behind Mr. Moore unannounced and clubbed him in the right temple. Hole in one, so to speak. He then suffered his heart attack or stroke, as a combined result of the physical exertion, the emotional impact of what he'd just done, and the brandy he'd been drinking."

"How do you know it was brandy?" Harris asked.

"That was his drink," Win replied. "And that was his club. And Mr. Moore was no favorite of his."

"So you're saying the murderer is in this room, and he's conveniently dead. Very tidy," the detective observed. "Seems he got away with it."

"No!"

The shout came from Carol Moore, who was shaking with rage. "My uncle did not kill Sheldon!" she cried. "That's not possible!"

A telephone rang twice before anyone spoke. Then Detective Harris said, "Why isn't it possible, Mrs. Moore?"

"Uncle Jonathan would never do such a thing," Carol answered simply.

"Are you saying he had no motive for killing your husband?"

Carol shook her head slowly. "I guess everyone will be glad

Sheldon's gone, including me, for that matter. But Uncle Jonathan didn't do it. He would never do such a thing. He wasn't a violent person."

Detective Ned Harris scratched his jaw and said, "Well, Mrs. Moore, I'm afraid that's not good news. You see, if we rule out Mr. Wise as the primary suspect in this case, I have no choice but to assign that role to you."

"Excuse me, Madam," James said from the doorway to the front hall. "Miss Sutton is on the telephone. She asked to speak with, um, Mr. Moore. I thought perhaps you'd like to speak with her?"

In the Rough

Barbara was late driving to the office on Wednesday morning. She didn't care.

She had never come in late before. Not once. Not even in the times when Sheldon would visit her in the middle of the night and the two of them would drink and misbehave for a couple of hours like brazen hamsters. Even then she always got to work on time. She prided herself on being a professional and an indispensable member of the office team. Usually she was the first to arrive, and she took perverse pleasure in giving late-comers—especially her boss—a gentle but stern disapproving look.

But this morning she was late. The hell with it.

She entered the Del Monte Forest through the Highway One Gate and the friendly guard waved her through. As she passed by him, he asked, "Did you hear somebody fell off a cliff last night?"

"Nope," she answered, and drove on. She didn't have time to chat, and her life was exciting enough as it was.

The business was in a state of chaos these days anyway. What

with Sheldon sitting on the panic button, private eyes snooping everywhere, Chip and Doug both nervous as cats, and Selia strutting around like a cocktail waitress all day long....

Barbara's mind was made up: if things didn't settle down to normal after this affair with the sultan's design blew over, she was going to hand in her notice.

In the meantime, if she was late to work on Wednesday morning, so what? So what if she was the last person to arrive, and she got paid back in stern looks from the rest of the staff?

But that's not how it worked out.

The parking lot was empty, except for Andy's motorcycle. And when she got to the front door of the office building, she found it locked. She opened it with her key, as usual, except that this morning it was nearly two hours later than usual.

She walked into the building and turned on the lights, then went to her desk and switched on her computer. The red light blinked on her answering machine: one message. She tried the door to Sheldon's inner office. Locked. She sat down at her desk and punched the play button.

"Hello, this is Greg Perry. I'm with Doug Banner, here at Monterey Community Hospital. Doug's in intensive care. He's had a serious accident, but everyone here seems to think he'll pull through okay. I just wanted to let you know he wouldn't be coming in today. He'll be out of work for a while. I don't know how long. I'm really...sorry. Oh, God, I'm *really* sorry...." Click.

Good Lord, Barbara thought. Poor Doug. What next? She put her purse under her desk and took a tour of the building.

The first office she came to was Chip's. She looked inside and gasped. The place was a shambles, a complete pigpen. Dirt all over the floor, all over the furniture, broken glass everywhere, books scattered like fall leaves. My God! she thought. What in the world—

"Welcome to Planet Pluto."

The voice made her jump like a rabbit. She spun around to face whoever it was who was breathing heavily behind her.

Putt. Huge and sweating, his shirt pulled out, his hair a mess, a pencil between his teeth.

"Andy," she said, "what are you doing here?"

"I work here," he replied. He took the pencil out of his mouth and wagged it between two fingers as he spoke. "At least I think I do. I'm not really sure of that. I'm not too sure of anything right now."

"What's going on around here?" Barbara asked.

"Don't look at me," he answered with an exaggerated shrug. "I didn't do any of this."

"Where is everybody?"

"Hell if I know. Like I say, I just work here."

"This is a disaster area," Barbara exclaimed.

"Check out Doug's office," Putt said.

She followed him along the hall and stepped down into Doug's office, and both sighed together. It wasn't as bad as Chip's office, but it was obviously the scene of a violent struggle of some sort. Doug's stool was turned over on its side. There were papers on the floor, and those papers that were left on the drawing board were soaking in a puddle of coffee. The coffee cup was upside down. Everything had been shoved off Doug's desk, and in the center of the otherwise empty space rested a blood-stained X-acto knife.

The phone rang.

Barbara lifted Doug's extension off the floor and answered it. She didn't announce the company; she simply said, "Hello?"

"Barbara, is that you? This is Chip."

"Chip, where the hell are you?"

"Sorry I'm late, but…listen, is Sheldon there this morning?"

Barbara exploded, "Chip, you tell me what's going on around here. What do you know about all this?"

"All what?"

"Okay," Barbara said. "Let's start from the top. Where are you?"

"Uh, I'm at Selia's house."

"Selia's house!"

"I came here to see if she's all right. She's fine. Actually, I spent the night here. I thought she might be in danger. In case you haven't heard, Sheldon's gone off his rocker. Big-time. Has he shown up at the office this morning?"

Jesus Lord, Barbara thought. "No."

"Good," Chip said. "I'll be right over. I've had it, Barb. That's it. I'm out of there. I'm going to come get my stuff. If Sheldon shows up before I get there, tell him to stay the hell out of my way. I'm packing my truck and then it's adios."

"Chip?" Barbara said.

"Yeah?"

"Don't hurry. I don't think Sheldon's going to make it this morning, and there's not much left for you to pack."

She hung up and realized that all the time she'd been talking to Chip she'd been staring at the oil painting on the wall over Doug's drawing board. What a beautiful piece of work! Too bad it was wrecked by that painful gash across the middle.

She sighed again and left Doug's office. When she came to Putt's office she looked in and found him seated at one of his computers. All the other machines were on as well. "So Andy," she said, "how come you're here all alone, and how come all the doors were locked when I got here?"

Putt looked up and said, "I got here at the regular time. I'm not the one who's weird around here. And when I saw what had happened, I locked the doors. Well? Wouldn't you?"

"Yes," she answered. "But I guess you may as well go home. I'll let you know when I find anything out."

"I'm not leaving till I back up my data on all my machines," Putt said firmly. "Before the next disaster strikes."

"Okay. I've got to make a phone call."

"911?"

"No. Sheldon's house. I want to know what the hell's going on. Then I'll call 911."

 Executive Course

Win had to hand it to them. The Monterey County Sheriff's Department did good work. They were pleasant personnel, they wasted no time, they didn't need to impress civilians with high-flown jargon, and they got the job done.

The medical examiner confirmed that Jonathan Wise had indeed died of a heart attack, probably about one A.M., possibly brought on by alcohol and strenuous exercise. His niece confirmed that he had had a history of heart trouble over the past several years, and James confirmed that the old man had been drinking brandy that night, against doctors' orders, although James had thought he'd taken the liquor away from him several hours earlier.

After the photographer took a roll of film, shooting the crime scene from every conceivable angle, Detective Ned Harris meticulously examined what was left of Sheldon R Moore III. From the stiffening of his body, it appeared that he too had died about one A.M. The cause of death was obviously a severe blow to the right temple, and it didn't take a genetic scientist to link the wound to the clubhead of the sand wedge. Sergeant Amy Worth dusted for prints, and she confirmed that the only prints on the golf club were those of Jonathan Wise, which were also the only prints on the nearly empty silver flask.

"Looks like an open-and-shut case," Win said. "Are you going to pursue it any further?"

"I wish I had a motive," Detective Harris said, addressing

everyone in the room. "Mrs. Moore thinks Mr. Wise wouldn't have done this, and from what I know of Mrs. Moore, I can't think she would have either. As a member of the community I'd like to let go of it, but as a policeman I have to be responsible here. Tell me, to anyone's knowledge, did the deceased have any enemies?"

"Hah!"

The voice came from the entry to the front hall. There stood Barbara Sutton, her eyes wide and a knuckle clamped between her teeth.

"Who are you, ma'am?" the detective asked. "And how did you get in here? Didn't you see this house is taped off?"

"Just the front part," Barbara replied. "I came through the garage. I have my own key." She held up her key ring and jingled it absentmindedly as she surveyed the living room. "My God, what a mess. Oh God, I never thought it would go this far."

"You have your own key?" Detective Harris asked her. He turned to Carol and demanded, "How many people have keys to this house?" Then he turned back to Barbara and said, "You never thought *what* would go this far?"

"Nobody," Carol said. "Barbara, I didn't know you had a key."

"Just to the garage," Barbara said. "Jonathan gave it to me. We used to meet there on Tuesday afternoons. I would bring him candy. And brandy. Oh Jonathan!" she wailed, crossing the room and kneeling by the sofa.

"Ma'am, I'll have to ask you to stay away from the bodies," Sergeant Worth told her. She gently took Barbara by the arm and led her to a chair and sat her down.

"Now then," Harris said. He puffed out his cheeks and let them relax. He scratched his head. He put his hands in his pockets and then he faced Barbara.

"Your name, ma'am?"

"Barbara Sutton. I am the business manager of Sheldon R Moore Golf Course Designs. Yes, I knew the deceased. Both of them. Yes, Sheldon had enemies, and I guess you could say I was

one of them. Yes, I have a key to the garage. No, I was not here last night, although I was in the garage yesterday afternoon. Any other questions?"

Harris chuckled. "You're pretty good at this. I think you've covered most of it. But, since you brought it up, exactly where were you last night about one in the morning?"

"San Jose."

"Were you with anybody?"

"No. I spent the night at the home of a friend, but he never showed up."

"Have you heard from him since?"

"Just a phone message. He was involved in an accident."

"Well, Miss Sutton, I'm afraid your own statements could cast a bit of suspicion on you. This isn't a formal questioning, you understand, but I'd like you to stay around town here for a few days until we get this matter all sewn up."

Win said, "Barb, what did you mean about it going this far?"

Barbara glanced nervously about the room. "You should see the office," she said. "Somebody's been there and trashed it. It's a mess. Now this. That's all I meant."

"The office? Someone vandalized it?" Carol exclaimed.

"Yes. Oh, yeah, and Doug's in intensive care at Monterey Community Hospital." Barbara's face crumbled into a sob. "It's all gotten out of control!" she wailed. "This was never supposed to happen!"

Win watched Ned Harris's face carefully. Finally the detective spoke. "It seems to me there's a lot to know that I don't know yet. I still think it's likely that Mr. Wise killed Mr. Moore, although he didn't have the motive that some others may have had, and wasn't a violent person, according to Mrs. Moore. It would be very convenient if I had some compelling reason to call this case closed, with the killer already called to justice by a higher power. But until that happens, it appears I have a job to do, and it starts by making a list of all the people who had a grudge against our

victim here."

"You can count me in," said a gruff voice from the terrace doorway. In marched Colonel Martin Ramsey, dressed in army fatigues, followed by his meek wife, Millie. "I believe in honoring the dead," the old soldier said, "but I certainly never honored him while he was alive. Look at him there. Shameful."

"Good Lord," Harris sputtered. "We obviously need better security here. How did you folks get in?"

"Beach access," Ramsey replied. "We traversed the meadow when we heard the news. We're reporting for duty."

"What the hell are you talking about?" Detective Harris shot back. "There's no news. There have been no media people here. Exactly who are you, and what do you want?"

"I don't listen to media news, officer," Ramsey answered. "Our team scans the police waves twenty-four hours a day. Intelligence work. We know everything you're up to, and don't you forget it. And when I heard what had happened, I knew you'd probably want to have this." He reached into his shirt pocket and produced a small audio cassette. He handed it to Harris. "With your permission, we'll be going now. Millie, about face."

"Just a minute," Harris barked. "You're not going anywhere until I learn your name and find out where you were last night at one in the morning."

Ramsey stood tall and stuck out his chest. "Colonel Martin Ramsey, Chairman of the Coastal Intelligence Agency. This is my wife, Millie. You'll find that tape very interesting. We'll be going now. We're late for a committee meeting, and...."

"Hold on," Harris said. "You haven't told me where you were last night."

Millie said, "We were out of town. We...."

"Shut up, Millie," Martin snapped. "Let me do the talking."

"Fine," Harris said. "Talk."

"I have a right to have my lawyer present," Martin insisted.

"Colonel, you're not being accused of anything here," Harris

responded. "I'm just trying to eliminate some possibilities. You seem to know your way around this property, and you yourself admitted that you were not overly fond of this man, who is now dead because somebody was not fond of him. Now if you can tell me where you were last night, and if we can verify that, it will make things simpler for all of us. What do you say?"

"We were in Salinas," Millie said. "No, Martin, let me talk. We stayed at the Laurel Inn."

"What were you doing in Salinas?" Harris asked.

"That's none of your damn business!" Ramsey shouted.

"No, I suppose you're right. I can't see how that would matter. I was just making conversation, Colonel."

"Martin had a golf lesson at the Salinas Country Club," Millie said, her head high and her chin defiant. She looked straight at her husband's flushed face and said, "He takes golf lessons every Tuesday afternoon, and we stay over at the Laurel Inn." She punctuated her statement with a little nod to her furious husband.

"I thought you hated golf," June exclaimed.

"Hating golf is a family tradition," Martin answered crisply. "This soldier believes in honoring traditions. Golf is an invention of the devil. I do hate it. But it's not going to defeat me, by God. I'm going to keep at it till I get my handicap down to ten, and then I swear to God I'm going to quit forever. Infernal game. Worst thing that ever happened to the human race. Golf! Who needs it?"

Millie shrugged and smiled. "He's a closet addict," she said, taking his arm. "But it's harmless. At least he doesn't drink or chew gum or watch football."

Martin Ramsey stared straight ahead at nobody. "Request permission to leave, sir," he said.

Detective Ned Harris smiled and said, "Permission granted."

The Ramseys left as they had come, through the terrace doors, Martin marching, Millie meekly keeping up behind.

"Well, people," Detective Harris said, "the time has come to take care of the deceased. I'll have to take custody of both bodies, I'm afraid; the coroner is going to want a closer look. In Mr. Wise's case, I expect we'll quickly determine that the death was by natural causes, and then I'll arrange to have him delivered to a funeral home, Mrs. Moore, if you'd like to make the arrangements."

"Oh dear," Carol said. "I'm afraid I wouldn't know how to begin."

"Forgive me, madam, but I'll be happy to take care of the arrangements," said James, who had appeared from the front hall. "And if you and the guests would like to repair to the library, I'll help the officers with their chores and put the living room back in order."

"Thank you, James."

"Not at all, madam. I'll be along shortly with some sandwiches."

When Carol, Barbara, Win, and June had assembled in the library, Carol said, "Barbara, what was that you said about Doug? He's been in an accident?"

"I don't know any of the details," Barbara answered. "Too much is happening all at once. But it appears that Doug and Greg were both involved in some sort of accident. Greg's okay, although his voice sounded really shaky. Doug's in intensive care. Meanwhile, the office looks like it was struck by lightning, an earthquake, and the Green Bay Packers. I don't know what that's all about, except that it couldn't have been done by Martin Ramsey."

"Well, I suppose we do have to figure out what's going to become of Sheldon's business," Carol said. "I'm counting on you to hold things together until we can come up with a plan."

"There's not a whole lot to hold together," Barbara said. "Chip's resigning, Doug's out indefinitely, Sheldon's, well, Sheldon's...."

Carol supplied the word: "Dead." No tears, not even a blush.

"I'll take care of accounts payable and that sort of thing," Barbara said. "But there's only one on-going project to worry about. And that's—uh-oh!"

"What?"

"The sultan arrives tomorrow! What are we going to do?"

"Well," Carol said, "I don't think there's much we can do. I'm not going to let him have this land, so I guess we'll just have to pay him back."

"The company can't afford to pay him back," Barbara said. "Sheldon spent the money. Now what?"

"Well, I guess we'll ask him to wait until we can raise the money, or part of it. In the meantime, let's just give him his design and beg for his patience."

"We can't, Carol," Barbara said. "Nobody knows where the design is."

James came into the library and set a tray of sandwiches and iced tea on the bridge table.

"Are you sure of that, Barbara?" June asked. "When was the last time you saw that design?"

"Haven't we been through all this?" Barbara fired back. "It's *missing*."

"Then what was that long package I saw you carry into the garage yesterday afternoon?"

Barbara's face turned fuchsia. She glared at June with her mouth trembling.

"Well?"

"Okay. That was the design. And yes, I had it all along, safe in the back of my van, inside one of Sheldon's putter boxes. I brought it here yesterday to show Jonathan. I knew how he'd feel about having his land converted into a golf course, and I figured he might want to do something about it. I was right. He asked to keep it. So he has it. He knows where it is. Too bad we can't ask him." She began to weep again.

Win said, "Maybe we should search his room."

"Mr. Winslow, please," James said. "I feel Mr. Wise would prefer if I were the one to search his room."

"Would you, James?" Carol asked.

"Of course, madam." He left.

"Now," Carol said. "I suppose we should get busy with some practical details. I'll write the obituary notices, and Barbara I want you to take them to the office, type them up, and fax them to the *Herald*, the *Sentinel*, the *Mercury-News*, *The Pine Cone*, and the *Chronicle* and any golf journals you think should receive them. Win and June, I'd like to prevail on you to arrange a memorial service at the Monterey Conference Center. Will you go over there and make arrangements?"

"Of course," June said.

Win was amazed with how capable Carol Moore had become in a matter of hours. "You're doing great, Carol," he told her.

She smiled. "I'm just doing my job. I've always been good at committee work." Then she turned to Barbara and said, "There's still something I'm curious about. What on earth possessed you to steal Sheldon's design for that golf course? Was it some kind of practical joke?"

"It wasn't just me," Barbara said. "We were all in on it."

"All?"

"Well, not Doug. He would never have gone for it."

"But why, Barbara? What a mess this has become."

Barbara sighed through her tears. "I know. We just wanted to keep Sheldon from closing the deal with the sultan until Greg Perry had a chance to make the sultan a competitive bid. But then Greg decided he wanted to present Doug's work, because he admired it so much, and he figured that if the job went to him, then Doug would come work for him, and, oh it's all so complicated, and it's all so wrong, and I really regret it, and God, I'm sorry, Carol. What a disaster!"

James appeared, wringing his gloved hands. "I'm sorry to re-

port that I found nothing unusual or out of place in Mr. Wise's bedroom," he said.

Carol laughed softly. "Well, perhaps it will turn up, and perhaps it won't. Frankly, I don't care that much. At least the sultan can't threaten Sheldon with bodily harm at this point. As for you, Barbara, I'm expecting you to meet the sultan's plane and do whatever it takes to keep him in a good mood. Do you understand me?"

"Yes," Barbara answered meekly.

"Whatever it takes," Carol repeated. "Now. Would anyone care for a sandwich?"

 Back to Basics

Win and June left the Wise mansion about half past two and went directly to the Monterey Conference Center, where they made arrangements for Sheldon's memorial service. Carol had decided that it would be a mistake to hold a double service, and that her Uncle Jonathan would not want that much attention paid to him anyway. Besides, the prevailing theory was that one of the dear departed had bumped off the other, and that could only lead to awkward conversation if both were honored in the same gathering. So Sheldon would be the headliner, and Jonathan could rest in peace.

They were fortunate. The Conference Center was able to accommodate them on Saturday morning at eleven. They went over the arrangements for the public address system, the janitorial maintenance before and after the affair, and the folding chairs—two hundred ought to be enough for all of Sheldon's friends, plus all the others who might be delighted to come to his funeral.

June phoned Carol to give her the news.

"That's perfect," Carol said. "I'll phone Barbara and have her add that to the obituary. She and I have already planned the service, and I'll order the programs today so they'll be ready by Friday afternoon. James can take care of the catering. So I think we're in good shape."

"Is there anything more we can do for you?" June asked.

"Well, I would like a hand on the day of the service," Carol told her. "But until then, I think you deserve a little rest. Why don't you do some sightseeing, maybe take a drive down to Big Sur?"

"We'll stick around town," June said. "In case you need us. You know how to reach us. Otherwise, I guess we'll see you at the service. Eleven A.M. Saturday."

"See you there," Carol said. "And don't you dare wear black!"

"I can't believe how cheerful she sounded," June remarked as she and Win strolled through the Monterey Bay Aquarium. "And so efficient."

"Well, she's been on volunteer committees for years," Win said. "She knows how to get things done, even if her husband never gave her credit for being capable. As for being cheerful, I suppose it's a bit soon to let it show."

"Let what show?"

"That life has suddenly become a lot more pleasant for Mrs. Sheldon Moore."

June gasped.

"That shocks you?"

"No," she said. "I was just looking at that giant squid." Then she said, "You don't think she did it, do you, Win? Murdered Sheldon?"

"I doubt it," Win said. "She's such a lady. But then, you never know."

"Do you even care?"

"Well, I'm curious," Win admitted.

"Me too. Let's get out of here. Too fishy."

They poked in and out of the shops on Fisherman's Wharf. There were the usual vendors: T-shirts and sunglasses, postcards and frozen yogurt. But the wharf also showed evidence of real fishermen at work, unloading real fishing boats that smelled like real fish.

"Talk about fishy," Win remarked.

"This is okay," June said. "It's natural. But it's not natural that Carol did it. Killed Sheldon. And I don't think Jonathan would do it either, even if he was a crusty old crab. I don't think he was the sort to kill somebody."

"He was drunk," Win reminded her.

"Still. Do you think anybody could have walked in through those terrace doors and covered his tracks?"

"It's possible," Win said. "If he was careful. But it's hard to imagine how he could have been careful under the circumstances. What about Barbara? She could have come through the house from the garage."

They bought ice cream cones and sat on a bench. "Let's see," June said. "Doug and Greg were both tied up in their accident, whatever that was all about. Chip and Selia can account for each other. By the way, what's that all about? Barbara can probably prove she was at Greg's house in San Jose—and what's *that* all about? The Ramseys were out of town. How about Andy? Putt, as he's known to his friends? Mr. Whiz Kid?"

"Nah," Win answered.

"Why not? I don't consider him a particularly stable person."

Win shook his head. "Too fishy."

When they arrived at the parking lot of Svendsgaard's they were met by Detective Ned Harris, who was leaning against his car and smiling.

"You look cheerful," Win said. "Have you solved the case?"

"To my satisfaction," Harris said. "I thought you'd want to know."

"Who won?"

"The Oscar goes to Jonathan Wise. Turns out he wasn't the sweet little old uncle his niece thought he was."

"Oh?" June asked.

"I listened to that tape Mr. Ramsey gave me," Harris explained. "It was from his answering machine. That Ramsey fellow is one eccentric individual, I must say. There were seven different messages, and every one of them, except one, was from a different member of what sounded like a vigilante group."

"So?" Win asked. "How does that affect Sheldon Moore's death?"

"One of the callers was Jonathan Wise, claiming to have proof that Sheldon Moore was going to convert his property into a golf course. He also said, in no uncertain terms, that he was planning Mr. Moore's demise. That he was going to do it himself. The call was placed last evening, about three hours before the crime was committed. That's enough for me, and apparently it's enough for Mrs. Moore. Case closed."

"Carol's heard the tape?" June asked.

"I had to play it for her to get her to verify the old man's voice. She was distressed of course, but I think she's relieved to know that as far as the Sheriff's Department is concerned, the investigation's over. She was also relieved to hear the coroner's report on her uncle. Natural causes. Heart attack. Massive and fast."

"I still say it sounds fishy," June said, her mouth full of toothpaste. "But I guess it doesn't matter. Nobody else seems to care, so why should we? But there's still one thing that is bugging me to pieces." She rinsed her mouth and spat into the sink.

"What's that?" Win said, massaging her shoulders.

"Whatever happened to that damned golf course design?" she answered. "The case of the missing links."

Tips for the Tour

Thursday morning as June was drying off after her shower, she heard Win talking to someone on the bedside phone. "Very good, then," she heard him say. "See you there at one forty-five."

She walked into the bedroom as he hung up the phone. Win had pulled the curtains open, and the picture window revealed a glorious day. "What was that about?" she asked casually. "Who were you talking to?"

He grinned. "Golf date at three o'clock. I'm finally going to get to play the Pebble Beach course. Looks like a great day for it, too." He stood up and stretched. "Isn't this great? An all-expenses-paid vacation, and now…what? What's wrong?"

June couldn't believe it. "Do you mean to tell me that the one day we finally get to relax together, you're going to leave me and go play golf? What are you grinning at? Win, I'm serious, and I'm pissed."

"Look at you, June," Win laughed. "You're beet-red from your nose to your toes. Is that because you just got out of the shower, or because you're mad at me? Or is it because you're stark naked in front of an open picture window?"

June whirled around and stomped back into the bathroom and slammed the door.

"Hey," she heard. "Open up. I have something to tell you."

June put on her bathrobe, practiced her phoniest smile, and opened the door. "Yes?" she said, a threatening lilt to her voice.

"Guess who I'm going to play with?" Win said.

"Sheldon R Moore the Third," she answered. "If you're not careful."

"You."

"Huh?"

"You, June. I want to play golf with you. I want to give you your first lesson. Will you spend the afternoon golfing with me?

Make me the happiest of men. Say yes."

What a cute man! What a nice person! June opened up her robe.

"You're blushing again," the golf nut observed.

She let the robe drop to the floor and crawled into his arms.

"You haven't had your shower yet," she told him.

"But you have," he said.

"I can take another. With you. Close those curtains."

After breakfast they strolled around the streets of Carmel, window shopping the art galleries and tourist boutiques. "I should probably get some equipment," June said. "I don't have anything to wear."

"What you have on will be perfect," Win assured her. "Slacks and a T-shirt with a collar. That's regulation dress for golf."

"Do I need spikes?"

"Not at all. Pebble's a soft spike course. Your sneakers will be okay."

"What about clubs?"

"We'll rent those."

"This is going to be an expensive afternoon," she said.

"Wait till you've done it. You'll find it's worth the money."

She squeezed his hand. "You're so good to me," she said. "Thank you for making me part of your golf game."

At the corner of Dolores and San Carlos they stopped in front of a window, where they saw a pewter chess set in which all the chessmen were golfers, wearing old-fashioned knickers and tams. "Robert Trent Jones, Jr. says that golf is like a giant chess game played between the designer and the golfer," Win told her.

"Who's he?"

"As of yesterday, he's the most famous golf course designer in the world. By the way," Win said. "I've engaged a caddy for this afternoon."

"Oh?"

"Yes. A Scottish caddy, no less. James the butler has the afternoon off, and he's agreed to come along and carry our clubs. We're going to be a classy twosome, you and I."

"This is a neat store," June said. "Look at that birdhouse on display."

"That's a replica of the clubhouse at the course they play the Masters on at Augusta, Georgia."

They walked through the Dutch doors into the shop, which was called Golf Arts and Imports.

"Welcome," said a genial looking man with white hair and black eyebrows. They nodded back. All around the walls were paintings and prints of golf scenes from nearby and faraway places. June nudged Win and pointed. "Look, that's one of Doug's."

"Nice, isn't it?" the man commented. "He's a local artist who specializes in courses designed by Sheldon R Moore the Third. They're considered the most beautiful courses in the world, and this artist captures them beautifully."

"He seems to have a strong affection for them," Win commented. "You've got quite a gallery here."

"Actually, it's not my gallery anymore. I'm just watching it for a few minutes while the new owner runs an errand." He sighed. "Retirement is rough. I used to have a travel agency, too. A golf travel agency. They called me the father of the escorted golf tour. Did that for more than forty years."

"You must be Mike Roseto," Win said. "I've heard of you."

They shook hands all around. "What was your favorite destination?" June asked.

"No contest," Mike answered. "Scotland. It has everything. Wonderful golf, great conditions, good hotels, friendly people. Perfect package." Mike thought a bit and then added, "Of course Ireland's more fun. Then there's Australia. And I'm crazy about New Zealand...."

"I like to travel, too," June said. "But I like traveling light. How do you manage with all the golf equipment? Especially if

you're shepherding a whole tour, and everybody's lugging around a big heavy bag. That must have been a headache."

Mike chuckled. "I like traveling light, too, and I have it down to a science. But some of my clients really learned the hard way. I had one couple who crammed both their sets of clubs into one bag in order to cut down on luggage. When we got to our first stop they found the heads of the woods had all snapped off."

"Ouch," Win said.

"Then there were the macho guys who brought the hugest, heaviest bags they could, just to be like the pros. Had a heck of a time finding anyone to caddy for them. The best caddies seem to end up with the lightest bags. Of course, a big bag comes in handy if you don't fill it full of clubs. I've known a lot of golfers to use their bags for dirty laundry. That's okay unless you get caught in customs and they make you empty it all out. See, golf bags are often used by smugglers, bringing back more than their limit of crown jewels or single malt scotch."

"That's pretty clever," Win said. "Using a golf bag to smuggle stuff."

"You see that antique golf print on the wall?" Mike said. "I brought that home in a golf bag. Wrapped it around my graphite driver, which was of course covered by the protective sock. Worked great, but when I went through customs I had a heck of a time convincing the official that I wasn't smuggling it. It was all legal, of course. I'd declared it on my customs form and didn't have to pay any duty because it was a work of art."

"This is a great store here, Mike," Win said. "Say, do you still get the itch to travel?"

"I still travel out to Seventeen Mile Drive," Mike answered. "Come to think of it, Pebble Beach has always been my favorite destination."

They had lunch in the Hog's Breath Inn, where the food tasted a lot better than June imagined it might. Win paid with a credit

card, and while they were waiting for the receipt, June said, "I think I'll call the mansion."

"What for?"

"I'm going to ask James to bring along Carol's golf clubs. She and I are about the same height. That will save us a little money."

"Good idea," Win said. "If Sheldon Moore bought them, I'm sure they're top of the line. He traveled first class all the way."

"Speaking of traveling first class," June said, "guess what's happening right now, as we speak...."

The Best Lie

Barbara got to the airport a half-hour early, asked around, and found out how to find the hangar that served the runway where the sultan's Lear Jet would land. She drove her car to the part of the airport that most travelers never see, parked it next to a white stretch limo, and walked around to the office to inquire about the status of the arriving flight.

On time. Good, Barbara thought. That gave her a few minutes to practice her repertoire of lies.

First, she'd have to start out with a piece of the truth: that Sheldon R Moore III was dead. Suddenly, unexpectedly, unfortunately, tragically...well, that was stretching it some. Anyway, dead. Totally dead.

Then what?

That might be enough. Sheldon R Moore III Golf Course Designs was a sole proprietorship, after all, and presumably the company, and all its obligations, ended with the death of the proprietor. Or was Carol now responsible for the company's debts? Ouch. In any case, Barbara was still on the payroll, and still the business manager, and she still had a sense of duty to the custom-

er. This customer had paid five million dollars for a design that didn't exist, or that nobody could come up with, and the least the company owed him was a decent lie.

My dog ate it.

Something to do with El Niño.

It was stolen. Stolen by gangsters. No, Elvis imitators. They came into the office with machine guns and held us hostage for forty-eight hours, scoured the joint, and made off with the design and my grandfather's watch and rode off on a rocket ship painted red, white, and blue.

Well, it *was* stolen, Barbara thought. She ought to know. The trouble is, nobody knew where it was now. But that wasn't really the trouble, either.

How about: Sheldon destroyed it himself, intentionally, just before he died. Committed suicide, taking the secret of the design with him to the grave? No, the details of his death would be in the papers.

The truth: the damn design was stolen, Sheldon kept it a secret from everyone, so there's no other copy of the design anywhere….

But that's not even true.

The truth: the design was based on a property that's no longer available. Was never Sheldon's to begin with. It was sold to the sultan under false pretenses.

The deal's off.

So what about about the five million dollars?

How about: Sheldon and the owner of the property, Mr. Jonathan Wise, had had a verbal agreement that the land would be used for the sultan's golf course. They were both in on it, but unfortunately they are now both dead, and there's this giant cloud on the title, and Sheldon's widow is being most uncooperative, and….

No.

Better stick with my dog ate it.

•

A jewel in the sky became bigger and bigger as it approached. It touched down on the runway and slowly taxied to the hangar, a royal purple jet with yellow squiggly letters across its side. It came to a halt, purred, sighed, and got quiet.

Here goes, Barbara thought. From the top, ad lib, ad hoc, hum a few bars, and play it by ear.

The door on the side of the plane swung open and a stairway dropped down. First came the guards. Six of them, all over six feet tall, all wearing black suits, brown skin, dark glasses, and fierce frowns. They waited at the base of the staircase, three on each side, while their sultan descended.

Barbara was pleasantly astonished to watch one of the richest, most powerful men in the world step out of his Lear Jet and down the stairs. He looked just like her Uncle Lenny. No turban, no robes, just a short bald guy with shiny shoes and a gold tooth in the middle of his big grin. His gray suit was beautifully tailored.

The sultan and his entourage strode across the tarmac, and Barbara stepped forward to meet him. "Welcome, your highness," she said. "Welcome to Monterey. To California and to America. My name is Barbara Sutton."

"Ah, yes," the sultan replied, shaking her hand and smiling graciously. "You are my friend Sheldon's assistant, right?"

"I'm actually the business manager of the company, your highness," Barbara answered. "But I actually have to tell you...."

"Business manager? Good. Then there are things we must discuss. Ah, that must be my driver."

Standing by the hangar was a uniformed chauffeur. The sultan spoke to one of his henchmen, who went to make arrangements with the chauffeur. Another member of the team went to supervise the unloading of the luggage.

The sultan offered Barbara his arm and said, "Shall we?"

Taking the sultan's arm, as if she were being led out onto the dance floor, Barbara said, "Thank you. Your highness, there are

some things I must...."

"Please," the sultan chuckled. "Don't call me 'Your highness.' You're much taller than I am. I have several names and several titles, but most of my business friends call me Haj. Will you do the same?"

"Hodge?"

"That will do. Will you ride with me in my limo, Miss Sutton?"

"Thank you, Hodge," she responded. "I'd be delighted. Please call me Barbara."

"Good. You see, I need your advice. I'm in a rather embarrassing position, and I want you to tell me how I should approach our mutual friend about it. Hmm? I need an ally, Barbara. Can I count on you?"

What do you say to a sultan?

"Of course you can, Hodge."

And as far as she knew, that was the truth.

 ## Down the Middle

"This is perfect," Win exulted, pulling into the parking lot of The Lodge at Pebble Beach. "A perfect spot, a perfect sport, a perfect day, a perfect partner. Everything is coming together."

He felt June's hand tighten on his thigh. "And look, there's James," she said.

Indeed, there he was, although it was hard to recognize him without his uniform. He stood beside the Rolls Royce, dressed in casual slacks and a golf shirt and cloth cap, and he was actually smiling. Sunlight and fresh air seemed to agree with him. Spotting them, he strode across the parking lot, a golf bag slung over one shoulder.

Win and June got out of the car and greeted him. Instead of the half-bow they were used to receiving, James offered his hand and said a word they'd never heard from him before: "Hi!"

"Good day for a game of golf, eh, James?" Win said as he opened the trunk of the Tracer.

"That it is, sir," James replied. "That it is. Here, let me get that." He reached into the trunk and pulled out Win's golf bag.

"I'll carry one of them," Win said.

"Quite all right," James said. "I've got them both. Shall we go sign in? I've checked, and we're on schedule to tee off at three. By the way, Mrs. Moore has taken care of the green fees."

They marched up the path to the pro shop. "Do you wish to ride, sir, or walk?" James asked.

"Walk," June answered.

"Very well," James said. "I'll be pleased to pack double."

"Very good, James," Win said. "Ready, June?"

"One question, coach," she said.

"Yes?"

"Standing between the two of you guys, how am I supposed to keep my eye on the ball?"

After they had outfitted June in a snazzy pair of socks, they walked out of the pro shop to behold one of the most beautiful and famous sights in the world of golf, the green expanse of the Pebble Beach Links.

"I could get used to this," June said.

"Me too," Win said. "This is a moment I've waited for for years."

"But Win, I'm afraid I'm going to ruin your afternoon. Instead of getting to play golf, you'll be stuck with me, a complete hacker. It's not going to be any fun for you if you have to go at my pace, and I can't keep up with you. I've never done this before, and...."

"Wait," Win said, laughing. "This will be fun for both of us. I

suggest, for this first lesson, you just follow along with me. You can watch everything I do. We won't keep score, and you don't have to hit your ball from where it lies. You can just drop a new ball from where I play each shot, and I'll coach you on how to hit it from there. That way we'll move at my pace, and we won't hold up anybody else. Until we get to the greens; then you're on your own. I've seen you play miniature golf, and I know you can putt."

"Okay," June said. "When do we get started?"

"We still have a few minutes," Win said. "I suggest the three of us go over by that tree, away from the other people, and I'll give you a few pointers on how to address the ball."

June and Win walked ahead, and James followed with the two golf bags, which he leaned against the tree.

"James, are you a golfer?" Win asked.

"I've played a bit, sir," James replied. "As a butler I've always felt it was my duty to be able to play a passable game of golf, a passable game of tennis, a passable game of bridge, and a passable game of chess. I'm no great shakes at any one of them, mind, but I can hold my own if necessary. Also squash, billiards, poker, and croquet. One never knows when one will be asked to fill in, you see."

"You take your duties very seriously," June observed.

"Yes, madam. But I'm a better caddy than I am a golfer, I must admit."

Win pulled a club out of his golf bag. "Of course you know, James, that I didn't ask you to come along just to caddy. There's the other matter we need to discuss."

"I assumed as much, Mr. Winslow," James answered.

"Call me Win."

"Thank you, sir. I'll try. Familiarity doesn't come easy to me."

"Well, I'll get right to the point," Win said. "Not that it matters to me, but you and I both know that Jonathan Wise did not kill Sheldon R Moore the Third. Fortunately, that's the verdict that everyone is happy with, but you and I know differently, am I right?"

"Yes, sir, I believe you are."

Win held out the golf club to the caddy and said, "Would you like to demonstrate the Vardon grip for June?"

James smiled and took the club.

Win turned to June and said, "Notice how he handles that sand wedge, June. Do you see anything special about that?"

"Well, not having done this before, I'm not sure what I'm looking for."

"But you do, don't you, James?"

"Yes, sir."

"You see, June, if I read the crime scene correctly, Sheldon Moore was killed by a tall, right-handed man with no fingerprints. Jonathan Wise was a short, left-handed man with fingerprints. You see before you a tall right-handed man wielding a sand wedge. I suggest you don't turn your back on him."

James laughed genially.

"Are you telling me you don't have fingerprints, James?" June asked. "You are a most unusual Scot, I must say."

"Oh I have fingerprints today, ma'am," James said. "But on Tuesday night I was still in uniform."

"White gloves and all," Win added.

The smile left James's face as he said, "If you think I should come forward...."

"Nonsense," Win said. "You have no right to claim the honor of having killed Sheldon Moore. Let the spirit of Jonathan Wise bask in that glory and in the gratitude of Sheldon's friends. I would be curious to know, though, how it happened. Blow by blow, so to speak."

James nodded. "I'm a man of few words," he began. "So if you don't mind I'll spare you the emotional part of this." It was clearly a difficult matter for him to discuss. "That was a most unpleasant evening. After Mr. Moore had left the house and Mrs. Moore had retired, Mr. Wise came downstairs, quite drunk. He was shouting about Mr. Moore and how he was planning to kill

him that very night and disinherit him the next day, which struck
me as a bit out of order, if not redundant. He was acting quite
wildly, and I was forced to take his sand wedge away from him for
fear he'd smash a lamp or two.

"Finally he passed out on the living room sofa, and I was
about to carry him upstairs to bed when I heard Mr. Moore com-
ing through the house. He sounded drunk as well. I was in no
mood to face Mr. Moore at that moment, and so I went out onto
the terrace to wait until he'd gone up the stairs. That's why the
terrace door was open, by the way. I stayed behind the door out
there, but under the eaves to keep my shoes dry. Mr. Moore came
out onto the terrace, mumbling gibberish, then went back inside
the living room. When I next looked in, there he was, bent over
Mr. Wise, trying to smother him. I don't think I need to tell you
the rest. I suppose I could have tried to reason with Mr. Moore,
but Mr. Moore was not a reasonable man in any circumstances,
and as I've said, I'm a man of few words. I still had Mr. Wise's
sand wedge in my right hand, and I did what was called for, I
believe. I was Mr. Wise's servant, after all. A servant does what a
servant must."

"So Sheldon killed Uncle Jonathan?" June asked.

"Perhaps," James answered. "He certainly tried. But the actu-
al cause of death may have been a heart attack. It doesn't really
matter, I suppose. I regret it either way, because I'll miss him.
However, I do not regret having taken action."

"Nor should you," June said.

"My only regret is that we never found that missing design,"
Win said. "That was the mystery we were hired to solve, and we
failed on that one."

June grinned. "Oh?" she said. "James, would you be so kind
as to demonstrate the Vardon grip again for me? Only this time,
please do it on the graphite driver from Carol's bag. That's the first
club I'll be using, after all."

"Certainly." James took out the driver, which was wrapped in

a full-length sock. He peeled the sock away and said, "Blimey! What's this, then?"

"James, what's happened to your Scottish accent?"

"Bloody hell, it's the missing design!" James exclaimed, unrolling the paper and holding it out for Win and June to see.

"Good Lord," Win muttered. "So it is!" A lovely rendering of meadows, greens, fairways, bunkers, trees, and a brown burn curving gracefully through the course, ending at the tip of the pelican's beak, emptying into the blue Pacific. "How in the world…?"

"Mike Roseto tipped me off," June answered. "I'd seen Barbara carrying what I assumed was the design into the garage on Tuesday afternoon, and she confirmed that she gave it to Uncle Jonathan. But nobody saw it after that. According to Detective Harris, Jonathan claimed in his phone message to Martin Ramsey to have proof of Sheldon's plans to convert the meadows into a golf course. That meant, I decided, that Jonathan still had the design stashed away somewhere, and that he was keeping it out of sight. I figured it was probably still in the garage, in a place where nobody would ever look. By all accounts, nobody's paid attention to Carol's golf clubs in months. When Mike told me about how he once wrapped a rare print around a graphite driver and protected it with the sock, I got a pretty strong hunch and phoned James to bring Carol's clubs with him this afternoon."

"So now what do we do with this valuable document?" Win wondered. "Give it to Carol? To the sultan? He paid for it, I suppose…."

"May I suggest, sir," volunteered James, "that I shred it at the earliest opportunity? I could toss it to the winds out here by the sea."

"No way," June answered. "Can't pollute the Bay. I say we wait till this whole thing blows over and then present it to Doug Banner. It's his artwork, after all."

"Okay, June, this is how it's done." Win stepped up to the tee and

said, "There's the matter of addressing the ball. You should re-
member four things: grip, alignment, stance, and posture."

"Gasp!"

"Huh?"

"That's how I'll remember them: grip, alignment, stance, and
posture. GASP."

"Right. Now watch." He addressed the ball. He looked out
over the fairway before him. He addressed the ball again. He lift-
ed his driver back, and with a motion so natural he didn't know
exactly what was happening except to know it was the second-
sweetest feeling in the world, he swung, connected, and followed
through. The white ball became a white dot sailing into the sky
until it dropped and bounced beautifully in the center of the fair-
way, far, far away.

"Very good, sir," James commented.

"Thank you, James. Okay, June, your turn. Now remember.
Don't expect to be perfect. You'll probably flub it completely, and
that's okay. Nobody gets it right the first time. And we're not keep-
ing score. Relax, now. Nobody's watching. The main thing is to
enjoy the swing. I'll watch you carefully and point out how you
can improve. Okay?" He teed a ball for her.

June nodded. James handed her the driver. She addressed
the ball. She glanced down the fairway, then looked down at the
ball. She pulled the clubhead away from the ball, back over her
back, then, with an amazing balance of might and grace, she
swung. Down and through. Inside to inside. The perfect swing.
Click!

The ball soared.

It landed and bounced. It was only a few feet from Win's ball.

In *front* of Win's ball.

"How's that?" she asked.

"Good Lord," Win exclaimed. "James, what do you think of
that?"

James laughed merrily. "Well, Win," he said. "If I was you, I

wouldn't give this lass any more lessons. And it's a good thing you aren't keeping score."

Properly Aligned

The weather on Saturday morning was perfect for an outdoor ceremony, even if the ceremony marked the passing of a prominent member of the community. Pennants fluttered in the light breeze, and the sun shone warmly on the assembled guests who filled the folding chairs and hushed to hear the last speaker deliver the final tribute to the man who had meant so much to all of them.

"Friends, colleagues, golfers," Barbara Sutton said into the microphone. "Please don't think of this as a sad day. Those of us who knew Sheldon R Moore the Third knew he would want us to remember him with smiles instead of tears.

"I'm not a sentimental person, and neither was Sheldon. He spoke the truth, and so shall I. He never hid his feelings, and nor should we.

"Many of us were touched by this man we honor today. Touched deeply. Touched in many ways. Those of us who worked with him and for him were challenged every day to find new ways to cope with new problems, and we grew under his constant supervision. Every one of us who worked with Sheldon, or dealt with Sheldon, or lived with Sheldon, is better off today because of the experience.

"Sheldon was a man who recognized the talents of others and made the most of them. Sheldon was a man who inspired us all to be hard workers and close friends, to be resourceful and to act on our convictions. He made our lives interesting, overwhelmingly interesting, every single day.

"The name of Sheldon R Moore the Third is well known to

every golfer who's ever tried to blast his way out of an impossible bunker, and I might add that some of us who knew him closely felt the same way from time to time. So let us remember Sheldon Moore as a hard worker, a strong businessman, a hearty friend, an untiring enthusiast, and, I might add, a scratch golfer.

"Thank you again for coming. Now on behalf of Mrs. Moore I invite you to mingle on the patio, and have a glass of one of Sheldon's favorite wines."

From the back of the crowd came the wail of bagpipes playing "Amazing Grace."

There was not a moist eye in the crowd.

"The bagpipes were a nice touch," June said to Chip and Andy as they sipped their Chardonnay. "Although I didn't think of Sheldon as Scottish. I've always thought Moore was an Irish name."

"I think every golfer has some Scottish blood in him," Chip said.

Chip and Andy were both more formally dressed than June had ever seen them before. Chip actually had on loafers instead of his hiking boots, and Andy wore a sportcoat over his plaid shirt.

"So what are you guys planning to do, now that the company is folding?" Win asked them. "Do you have any plans?"

The young men glanced at each other and both grinned. "As a matter of fact, we do," Chip said. "We're going into business together. Chip 'n' Putt Enterprises."

"Good for you," June said. "Something to do with golf, I presume?"

"Computer games," Andy said. "Golf games. Like the one you saw in my office."

"Carol Moore has given us the electronic rights to all of Sheldon's designs," Chip explained. "There are three hundred of them. That should keep Andy busy for a while."

Andy shrugged and grinned.

"And what will you do for Chip 'n' Putt Enterprises?" Win asked Chip.

"Ground work," Chip answered. "I'll deal with lawyers and bankers. Dirty work's my specialty."

"So it's just the two of you?" June asked.

Chip grinned and blushed. "Well, Selia's on board, too."

"I haven't seen Selia here today," June observed.

"She didn't come," Chip said. "She and Carol decided it wouldn't be appropriate. But Carol's letting her keep the house in Pacific Grove. In fact, that's where we'll set up shop."

Greg Perry joined them and shook hands all around. "So how's Doug doing, Greg?" Chip asked.

"Well, he's out of intensive care," Greg said. "Carol has offered to cover all the medical expenses, and she's got him in a private room. He's getting better every day."

"Glad to hear it," June said.

"Me too," Greg said. "I would never have forgiven myself if he hadn't pulled through."

"What happened, anyway?" Win asked. "We never heard the full story."

Greg sighed. "I have a lot to atone for," he said. "I was drunk that night, and I was furious with Doug Banner for rejecting my offer. So I went to the Tap Room at the Lodge and got smashed. Just hammered. Then, as I was leaving, I saw Doug come out of Sheldon's office building and get into his car. I followed him, and when he pulled into the parking lot of Stillwater Cove I parked out on the road. That was probably for the best, actually, because I had no business driving. Anyway I grabbed a club out of the trunk of my car—don't ask me why—and I went out onto the golf course looking for Doug. I finally caught up with him at the sixth hole. By that time I wasn't mad at him any more, but I decided to have a little fun at his expense, so I started hitting balls at him. NiteLites. I know, it was a crazy thing to do. I just meant it as a joke, but it scared him, or

at least it startled him, and, well…so that's how he ended up in the hospital."

June laid her hand on Greg's shoulder and said, "It was a stupid thing to do, but you've got to forgive yourself. I'm sure Doug will forgive you."

"He already has," Greg said. "As a matter of fact, he's agreed to come work for my firm, as soon as he's able. I'm making him a full partner, and I'm insisting that he get full credit for every golf course he designs."

"Looks like everybody wins in this game," Win said.

"There's Carol," June said. "Over there talking to the Ramseys. Come on, Win, let's go pay our respects before we drive back to Burlingame."

They walked across the patio and were met by the smiling, gracious widow.

"Thank you both so much for making the arrangements," Carol said. "I think it's turned out beautifully."

"So lovely," Millie said. "Such a lovely day, don't you think?"

Even the colonel smiled. The smile didn't look natural on his face, but then nothing about Martin Ramsey ever looked natural.

"We've been hearing about your generosity, Carol," June said. "You must have had a busy day yesterday, doing so many nice things for so many people."

Carol laughed. "I've been having the time of my life. Did you hear I'm going to move? I've made a bid on a house by the Monterey Peninsula Country Club."

"How nice," Win said. "But what's going to happen to Pelican Point?"

"I'm giving it to the Audubon Society," Carol said. "And Martin and Millie are going to live in that drafty old mansion and manage the place."

The Ramseys beamed.

"What about James?" June asked. She nodded in the direction of the table across the patio, where the handsome butler, in

full uniform, white gloves and all, was opening wine and giving instructions to one of the servers.

"He's offered to stay with me and manage my new household," Carol said, a smile growing on her face. "What could I say?"

"If I were you," June said, "I'd say yes."

Carol's smile grew almost out of bounds. "That's exactly what I said. Oh, by the way, June, there's one more gift I want to bestow before I'm done."

"Oh?"

"I want you to have my golf clubs. James tells me you're quite a golfer."

"Beginner's luck," June said, blushing. "Thank you!"

"Except the sand wedge," Carol added. "We're going to bury that with Uncle Jonathan. It's his wealth that's being spread around today."

"Well, this day has brought blessings to everyone," Millie Ramsey gushed. "Sheldon ought to be very pleased."

"You're right, Millie," Carol said. "He ought to be pleased. That's not to say he *would* be pleased, but he ought to be."

"And what about Barbara?" Win asked. "What's in store for her?"

"Haven't you heard?" Carol said. "She has a new business partner."

"Oh?"

"Oh yes indeed. She'll be living half the year in Malaysia and half the year here in California, managing the sultan's new investments. She's going to help him acquire and develop vineyards and wineries up and down the state. It seems he grew tired of golf, but if Barbara has her way he'll never grow tired of wine."

"Wineries?" Martin Ramsey exploded. "Wineries! He better not build any god damn wineries in this county, by God! We have too many wineries in Monterey County as it is. If he comes carpetbagging in here, tearing up our lettuce fields and chopping

down our precious oaks, I'll fight him tooth and nail, by God! He won't get away with this!"

"There, there, Martin," Millie said, patting his arm. "There, there."